DRAW
COLOR & STICKER
NATURE
SKETCHBOOK

© 2016 Quarto Publishing Group USA Inc.
Illustrations © 2016 Katie Vernon

This edition published in 2019 by Crestline,
an imprint of The Quarto Group
142 West 36th Street, 4th Floor
New York, NY 10018 USA
T (212) 779-4972 **F** (212) 779-6058
www.QuartoKnows.com

First published in 2016 by Quarry Books, an imprint of The Quarto Group, 100 Cummings Center, Suite 265-D, Beverly, MA 01915, USA.

Crestline titles are also available at discount for retail, wholesale, promotional, and bulk purchase. For details, contact the Special Sales Manager by email at specialsales@quarto.com or by mail at The Quarto Group, Attn: Special Sales Manager, 100 Cummings Center Suite 265D, Beverly, MA 01915, USA.

10 9 8 7 6 5 4 3 2

ISBN: 978-0-7858-3803-6

Cover Image: Katie Vernon
Design and Page Layout: Megan Jones Design
Illustration: Katie Vernon

Printed in Singapore COS112020

DRAW
COLOR & STICKER
NATURE
SKETCHBOOK

AN IMAGINATIVE ILLUSTRATION JOURNAL

» *Katie Vernon* «

CRESTLINE

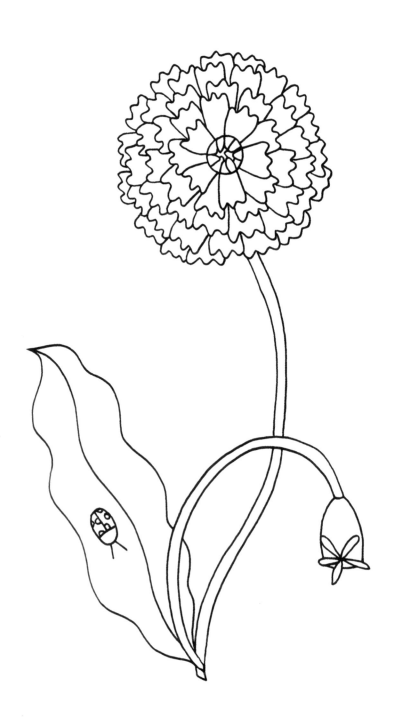

WELCOME!

HOW TO USE THIS BOOK

THE DESIGNS FEATURED IN THIS BOOK ARE SET UP IN PAIRS. THE FIRST TWO PAGES CONTAIN A FULL DRAWING, READY TO COLOR. COLOR WITH CRAYONS, COLORED PENCILS, COLORED MARKERS, OR EVEN WITH WATERCOLORS. IF YOU'RE FEELING ADVENTUROUS, DRAW IN A FEW EXTRA DETAILS WITH A PERMANENT MARKER, AND EMBELLISH WITH STICKERS BEFORE YOU COLOR. THE SECOND TWO PAGES IN THE PAIR CONTAIN A PARTIAL DRAWING WITH A SIMILAR DESIGN. YOUR TASK IS TO COMPLETE THE DRAWING. LOOK AT THE FINISHED DRAWINGS FROM THE PREVIOUS SPREAD FOR INSPIRATION, OR DOODLE FROM YOUR OWN IMAGINATION. A FINE-LINE, BLACK PERMANENT MARKER WILL COMPLEMENT

AND BLEND IN WITH THE ORIGINAL DRAWING, BUT FEEL FREE TO DRAW USING ANY TOOLS AND COLORS THAT APPEAL TO YOU. EACH DESIGN THEME HAS A COORDINATED STICKER PAGE IN THE BACK OF THE BOOK. YOU CAN DRAW AND COLOR RIGHT ON TOP OF THE STICKERS TOO. THE LAST TWO STICKER PAGES ARE EXTRAS THAT CAN BE USED ANYWHERE. USE THE COORDINATED STICKERS, OR MIX AND MATCH THROUGHOUT THE BOOK TO CREATE UNIQUE DESIGNS IN YOUR OWN VISION.

FOLLOW THE PROMPTS AS YOU DRAW, COLOR, AND STICKER YOUR WAY THROUGH THIS BOOK. MOST IMPORTANTLY, HAVE FUN, AND TAKE CREATIVE CHANCES! THE RESULTS MAY SURPRISE YOU.

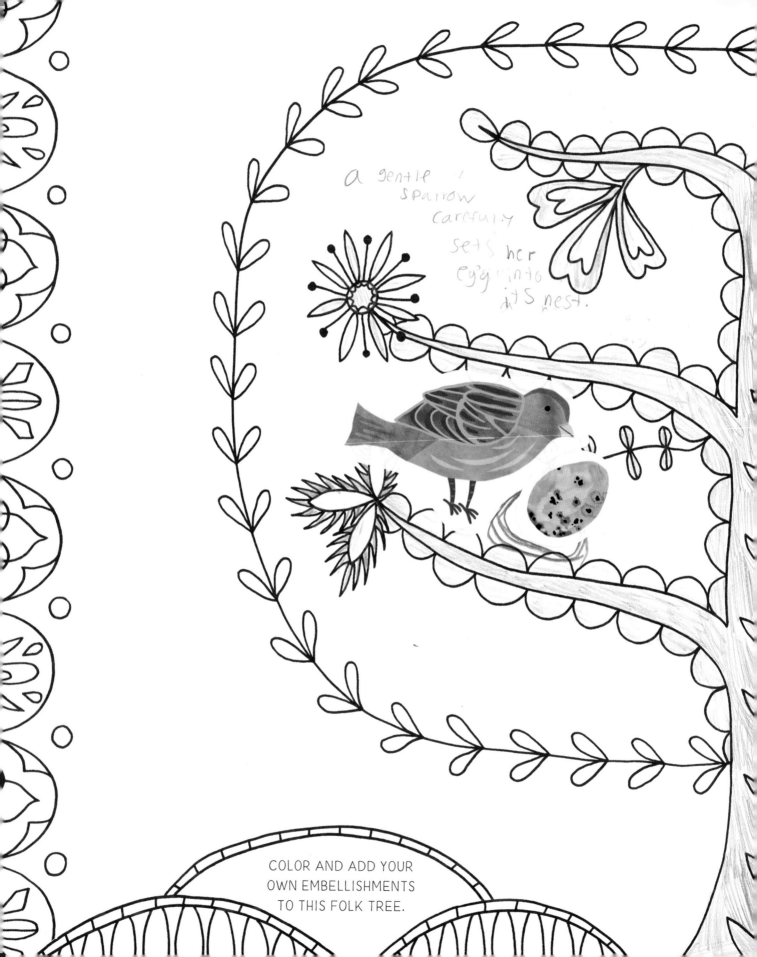

a gentle
sparrow
carefully
sets her
egg into
its nest.

COLOR AND ADD YOUR
OWN EMBELLISHMENTS
TO THIS FOLK TREE.

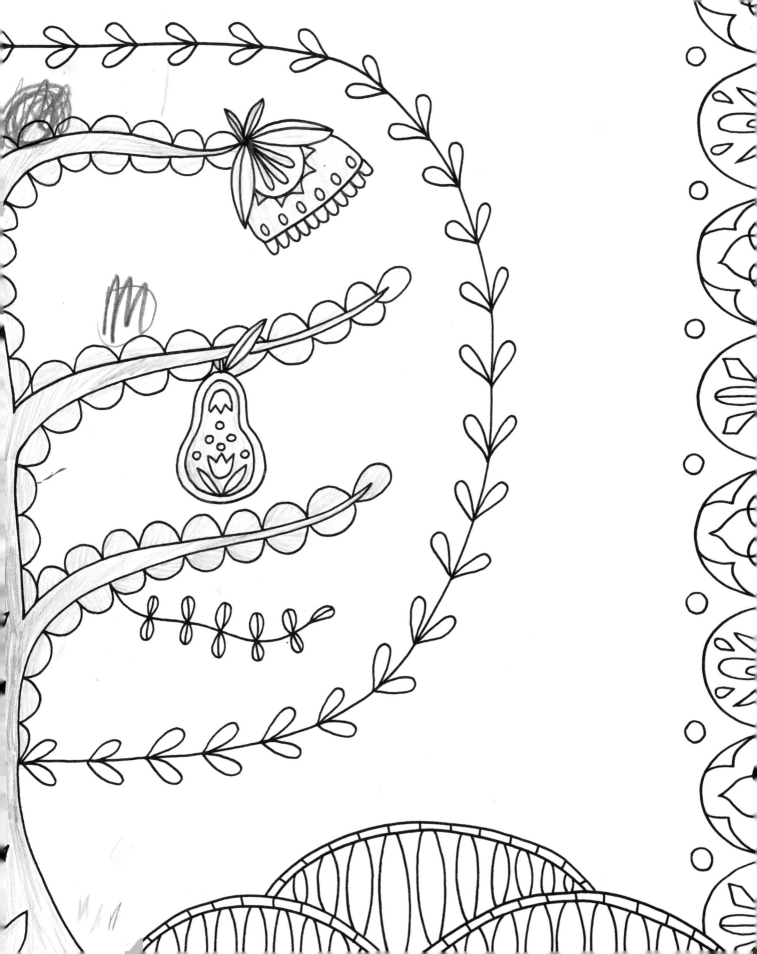

DRAW FOLKY DETAILS AND
DECORATE WITH STICKERS.

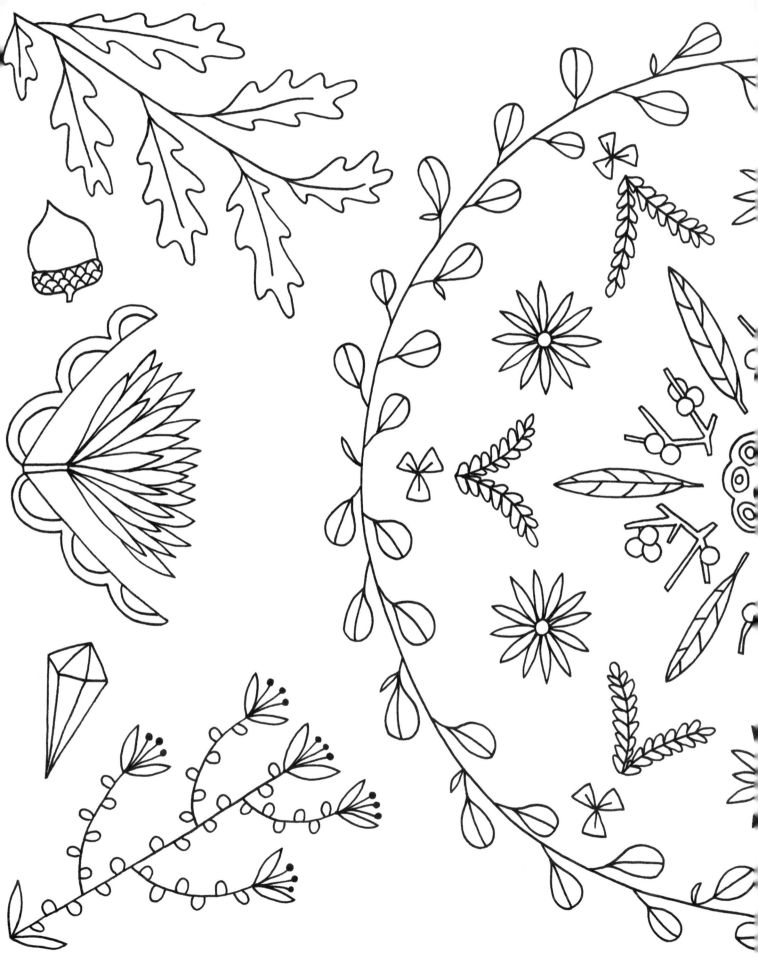

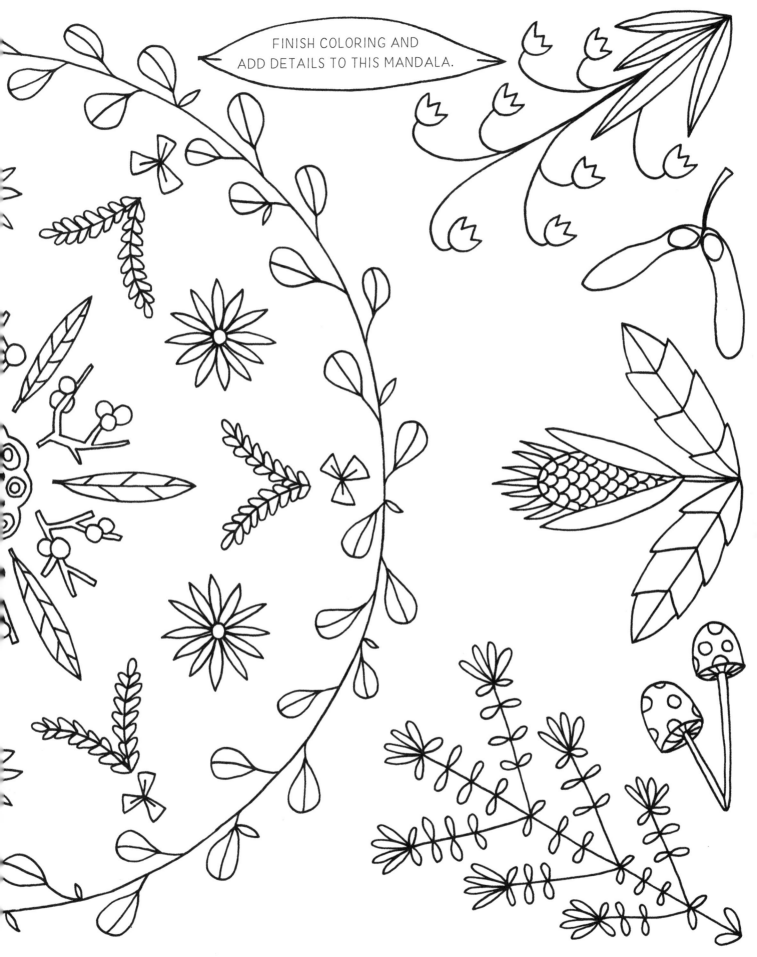

FINISH COLORING AND ADD DETAILS TO THIS MANDALA.

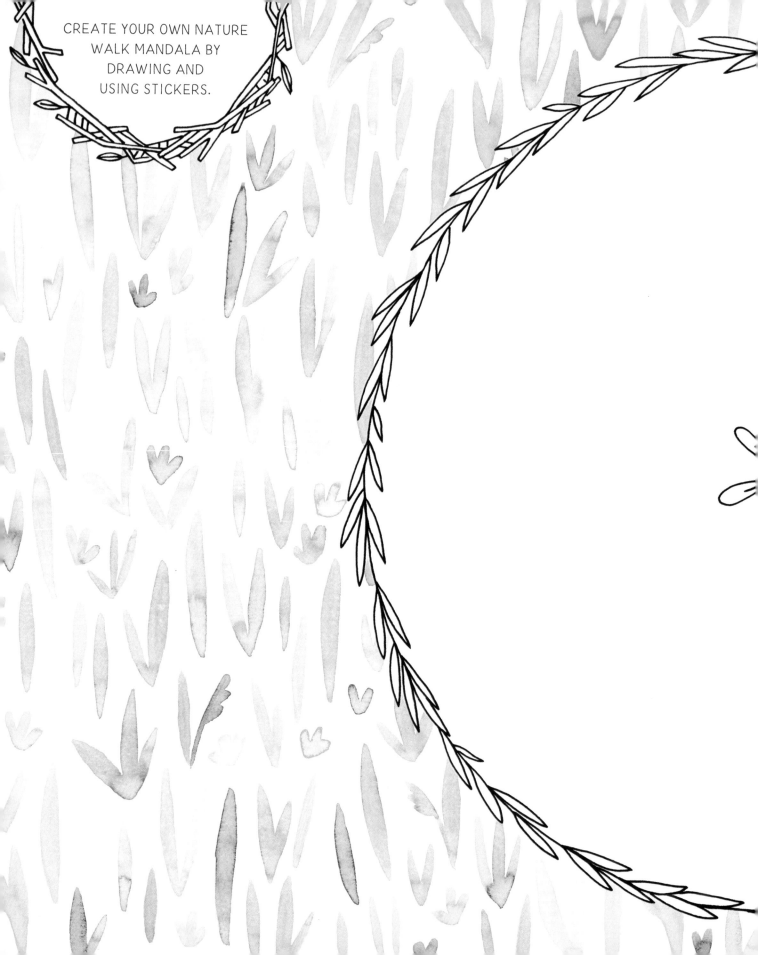

CREATE YOUR OWN NATURE
WALK MANDALA BY
DRAWING AND
USING STICKERS.

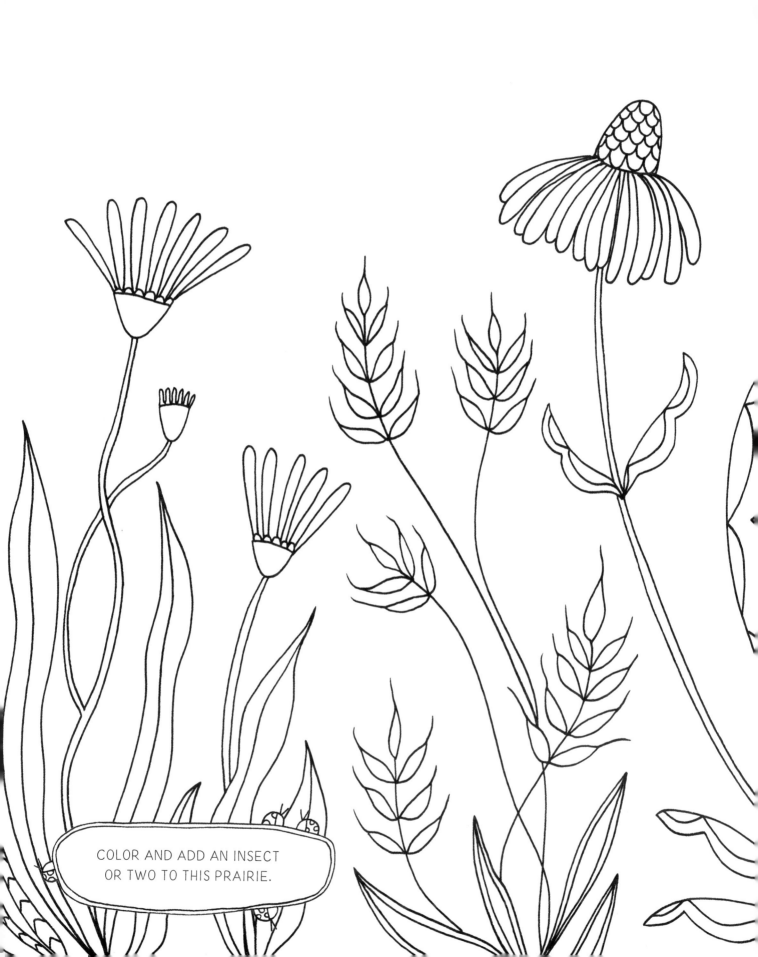

COLOR AND ADD AN INSECT
OR TWO TO THIS PRAIRIE.

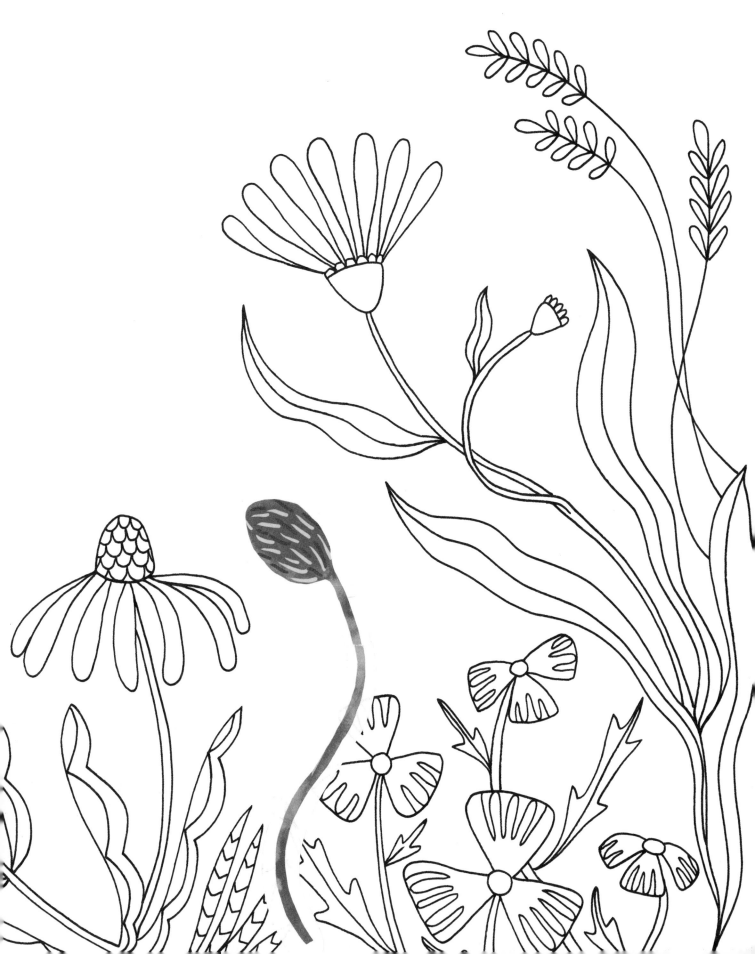

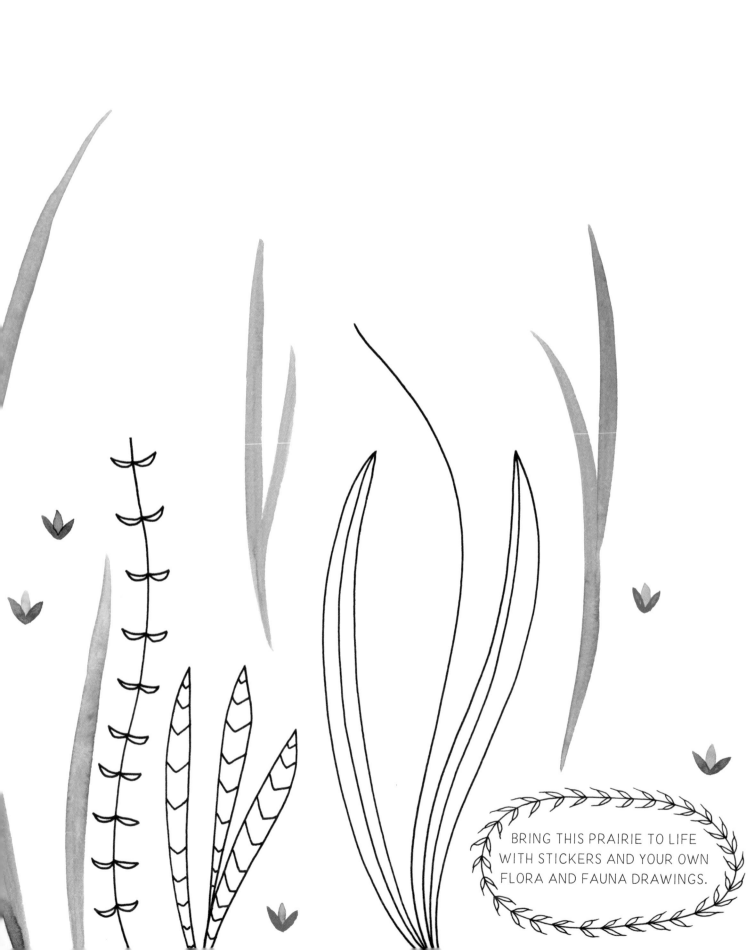

BRING THIS PRAIRIE TO LIFE
WITH STICKERS AND YOUR OWN
FLORA AND FAUNA DRAWINGS.

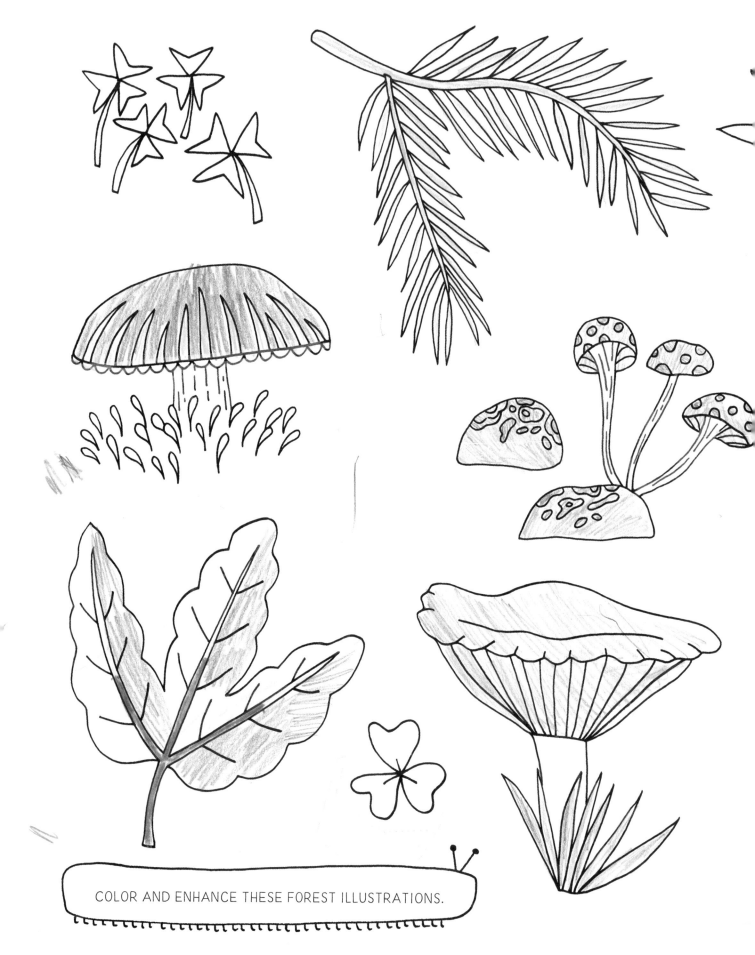

COLOR AND ENHANCE THESE FOREST ILLUSTRATIONS.

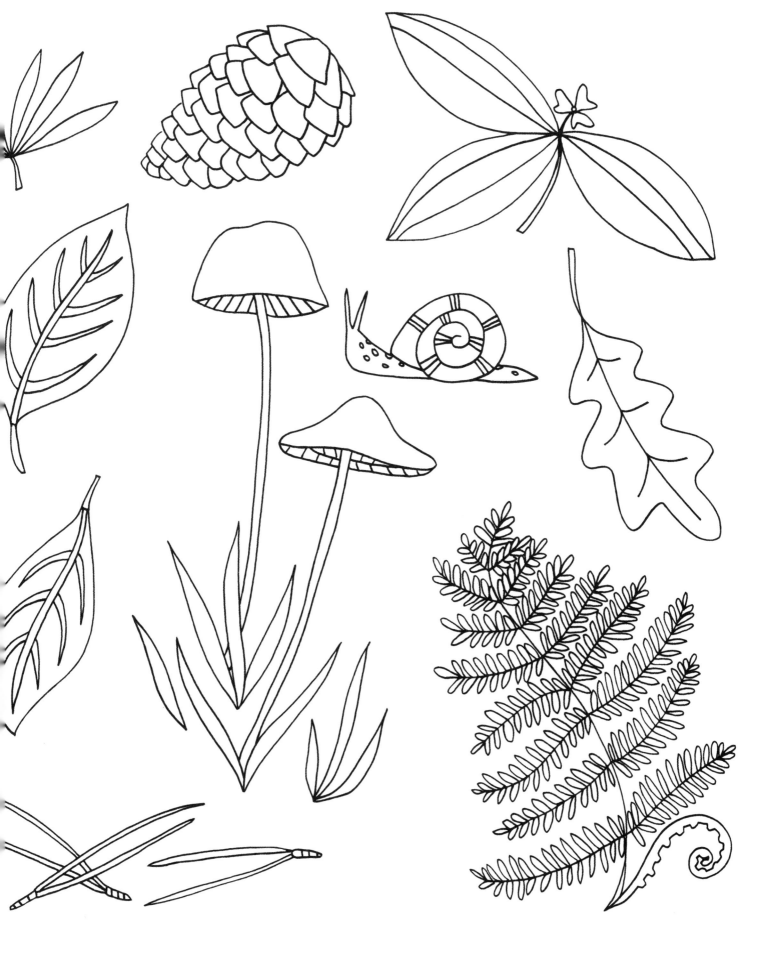

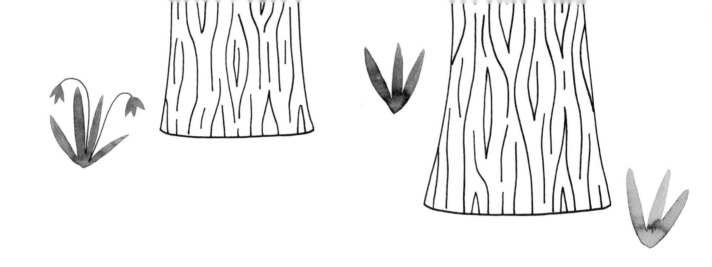
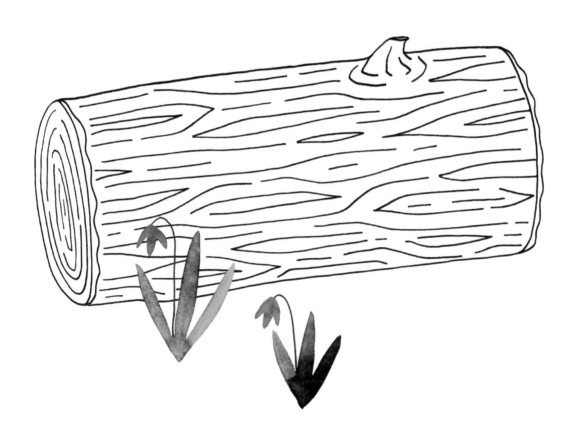

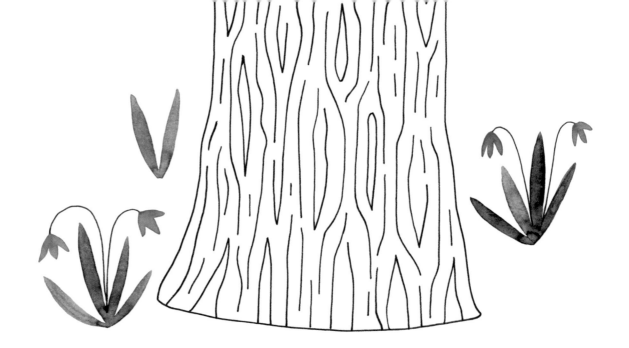

ENLIVEN THE
FOREST FLOOR WITH
THE STICKERS AND YOUR OWN DRAWING.

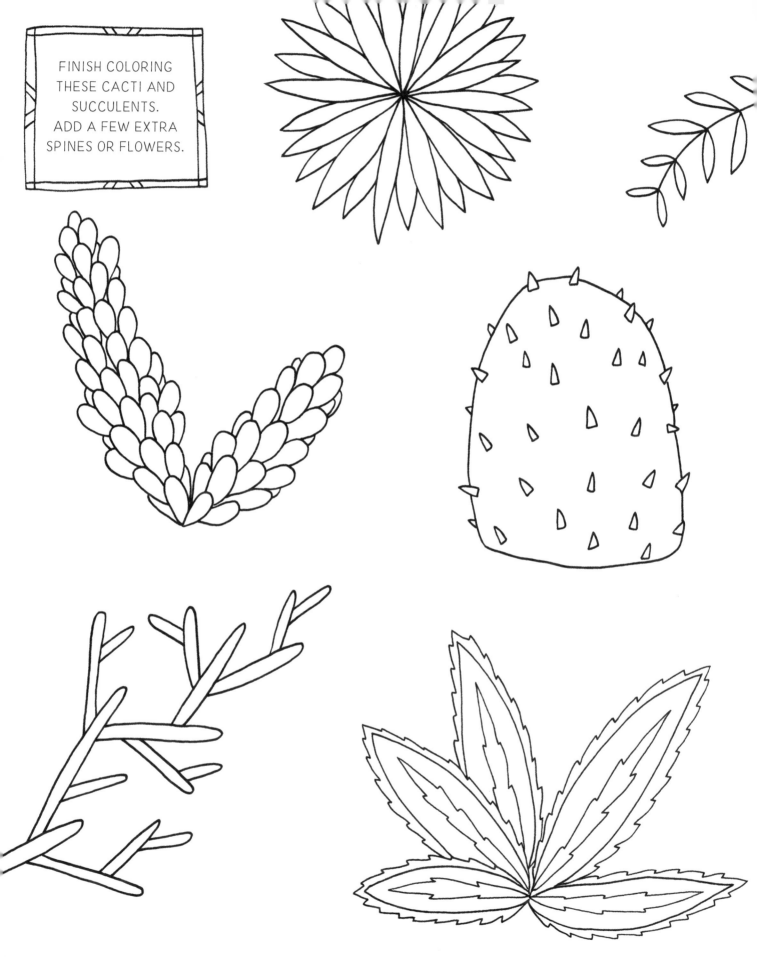

FINISH COLORING
THESE CACTI AND
SUCCULENTS.
ADD A FEW EXTRA
SPINES OR FLOWERS.

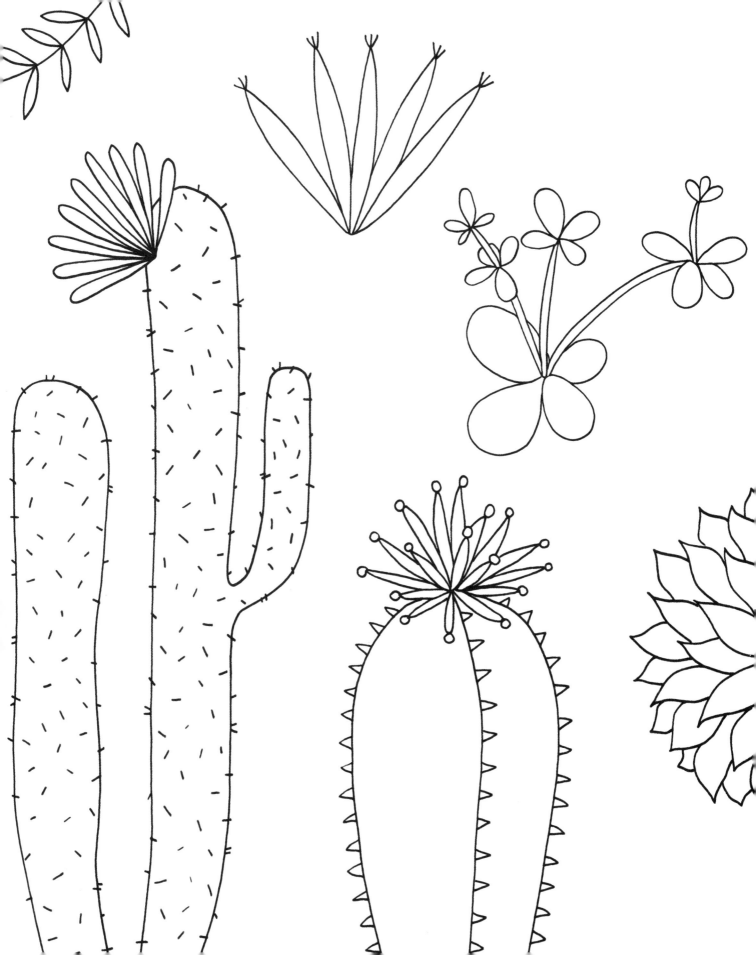

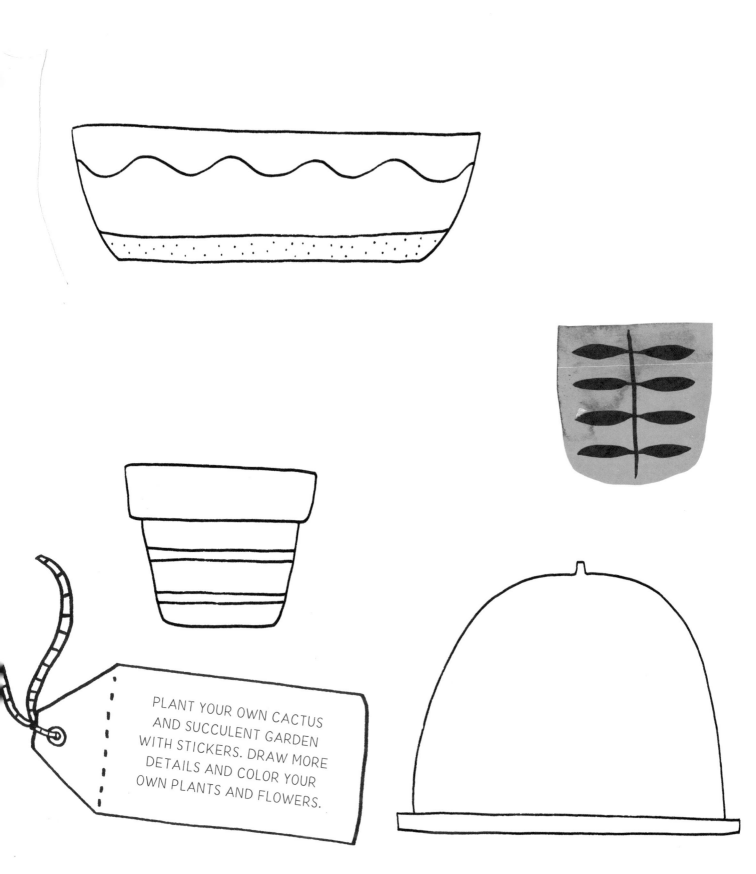

PLANT YOUR OWN CACTUS AND SUCCULENT GARDEN WITH STICKERS. DRAW MORE DETAILS AND COLOR YOUR OWN PLANTS AND FLOWERS.

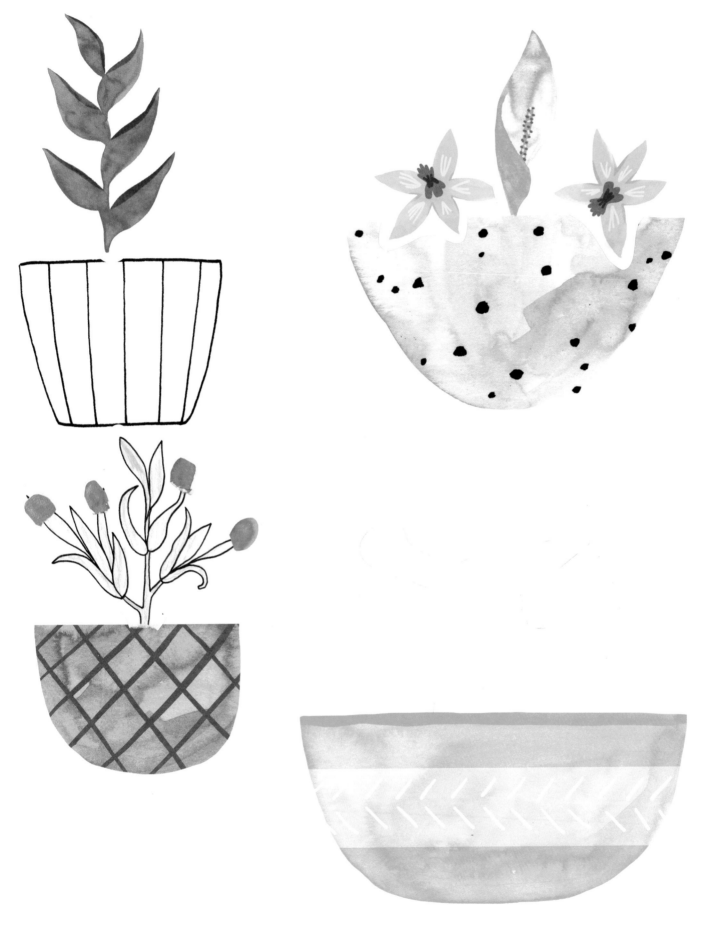

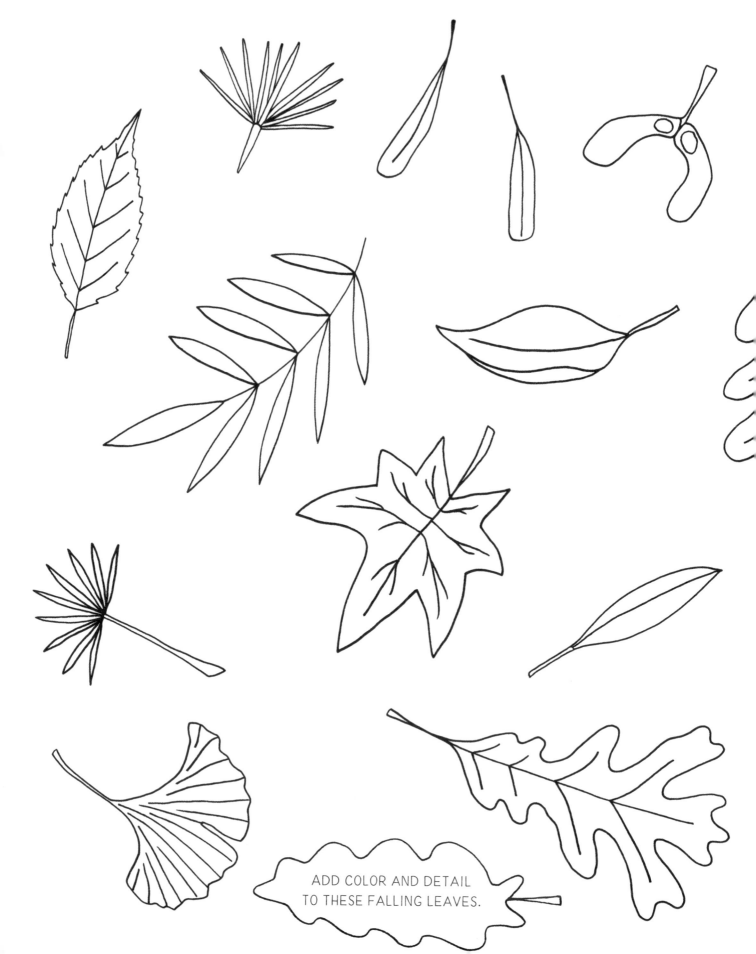

ADD COLOR AND DETAIL
TO THESE FALLING LEAVES.

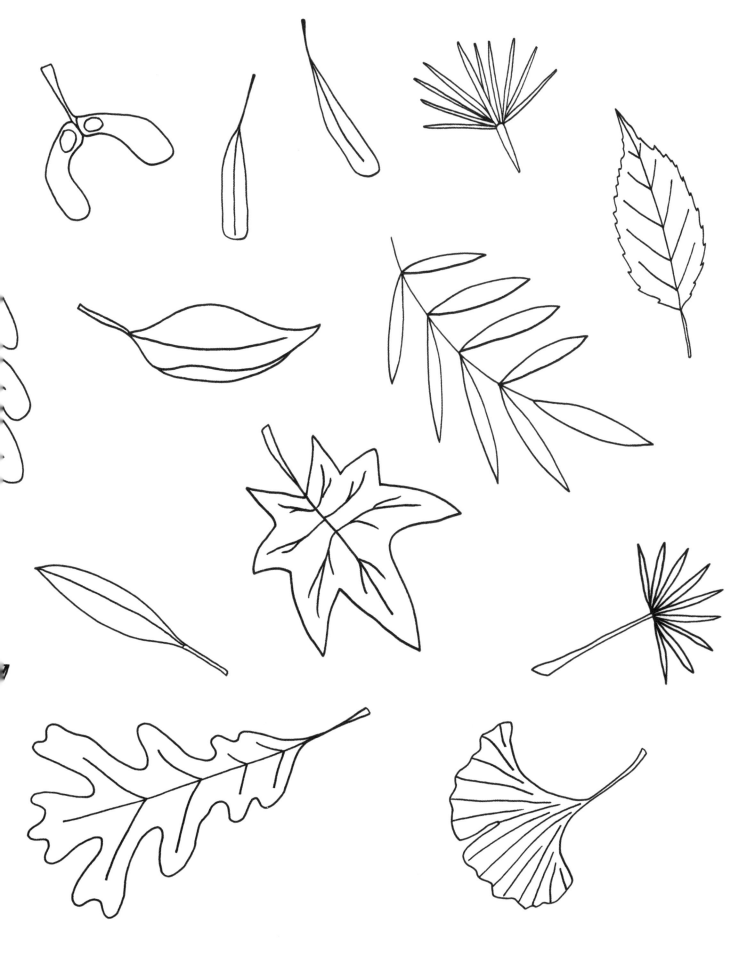

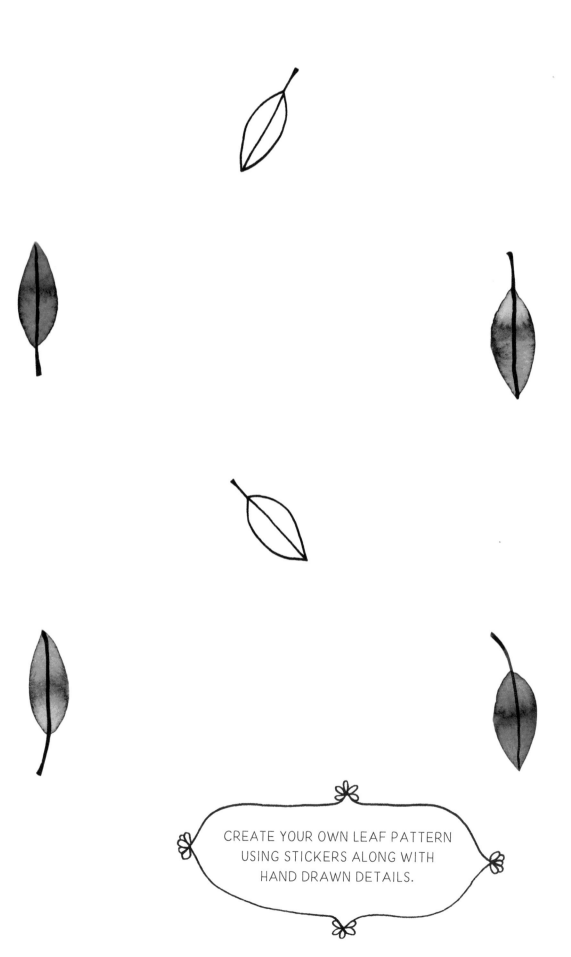

CREATE YOUR OWN LEAF PATTERN
USING STICKERS ALONG WITH
HAND DRAWN DETAILS.

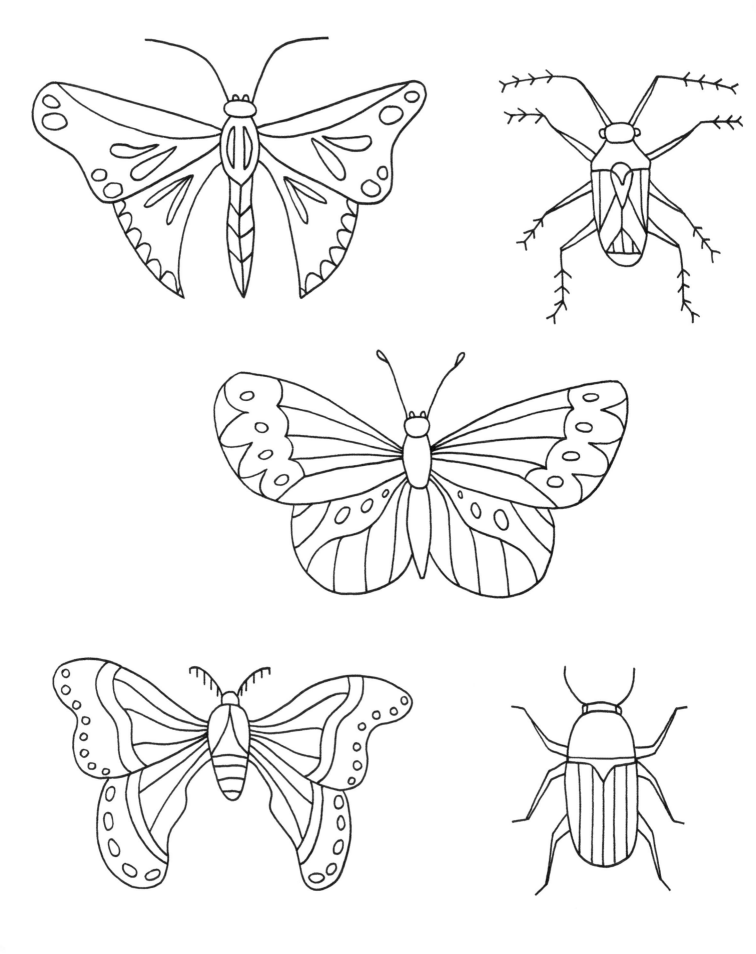

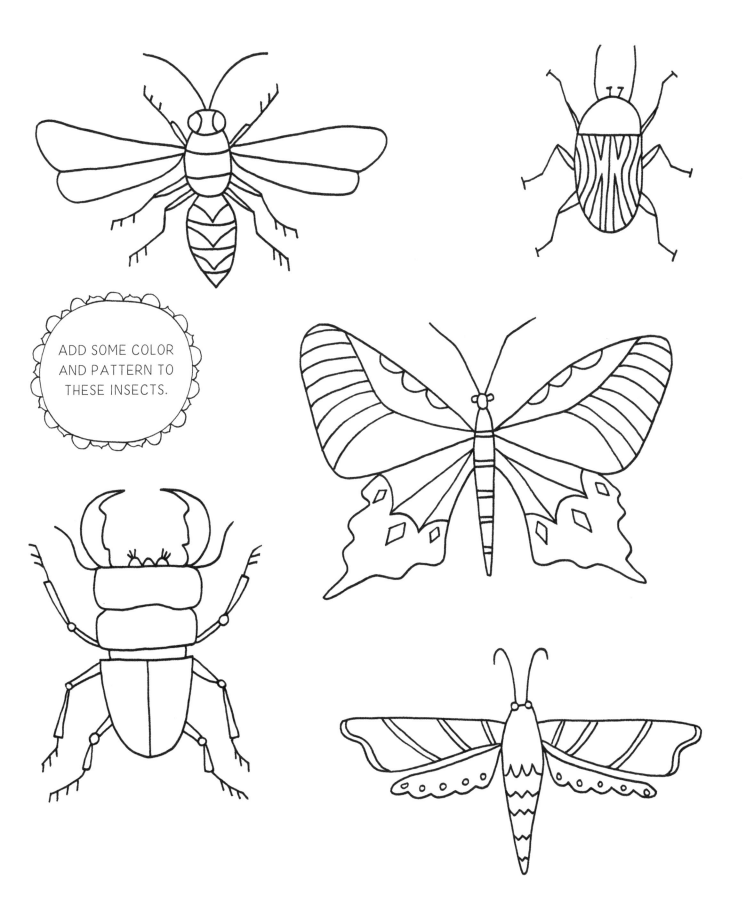

ADD SOME COLOR AND PATTERN TO THESE INSECTS.

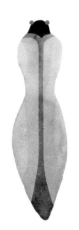

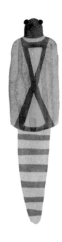

CREATE YOUR OWN
INSECTS USING STICKERS.

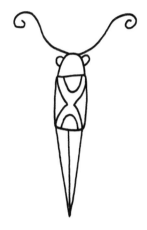

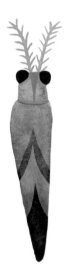

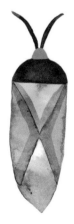

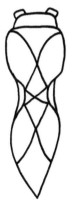

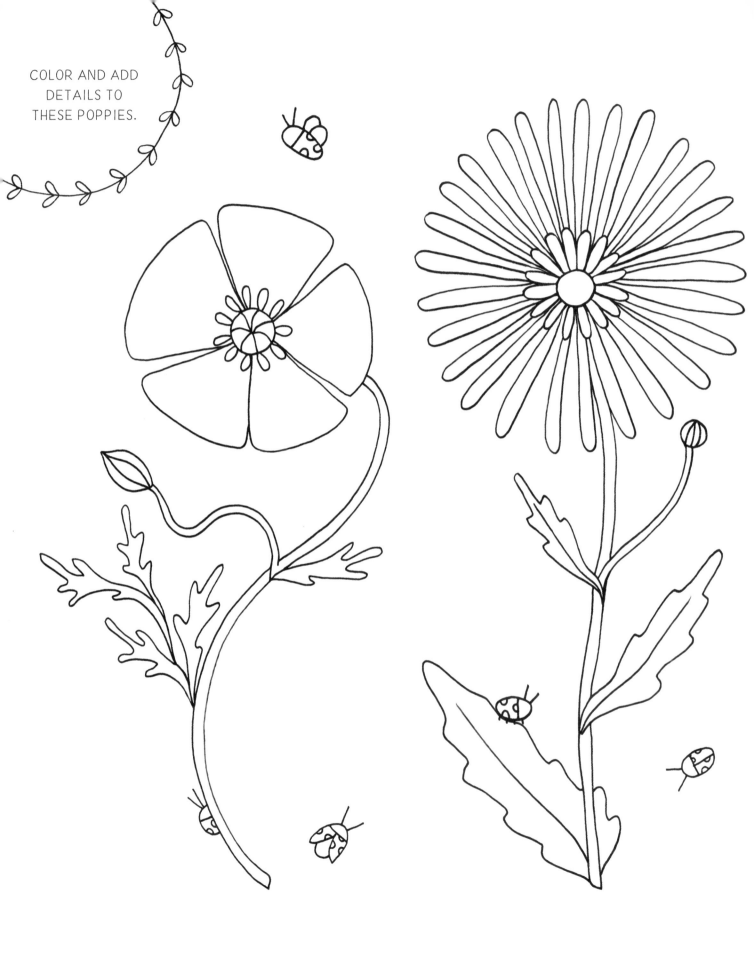

COLOR AND ADD
DETAILS TO
THESE POPPIES.

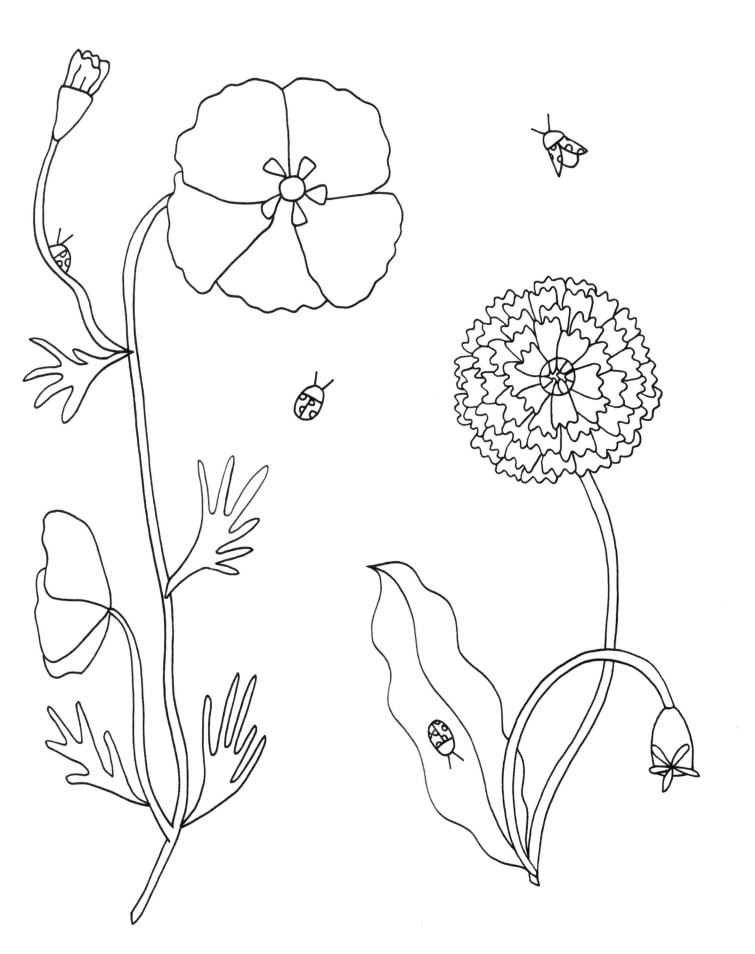

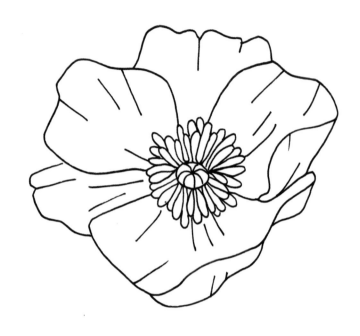

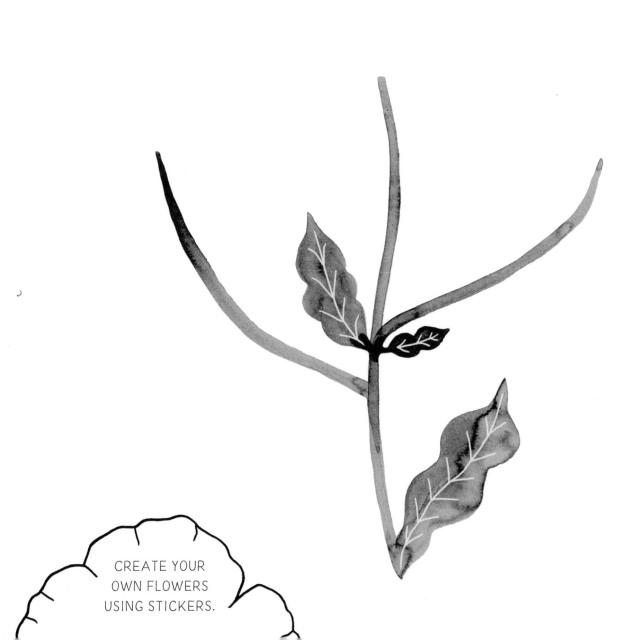

CREATE YOUR
OWN FLOWERS
USING STICKERS.

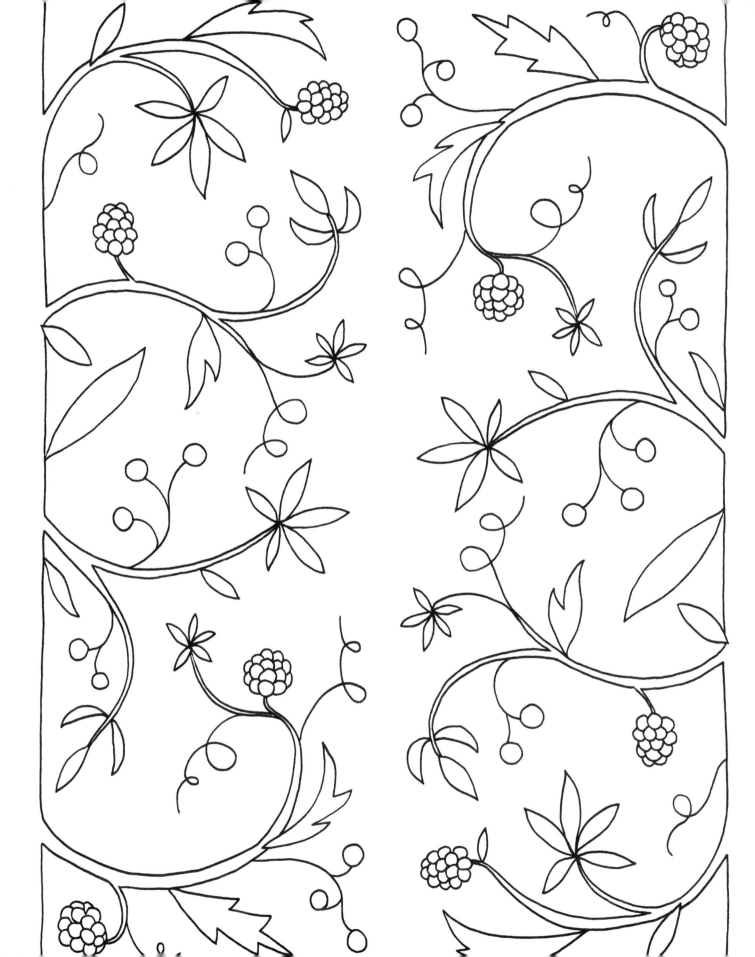

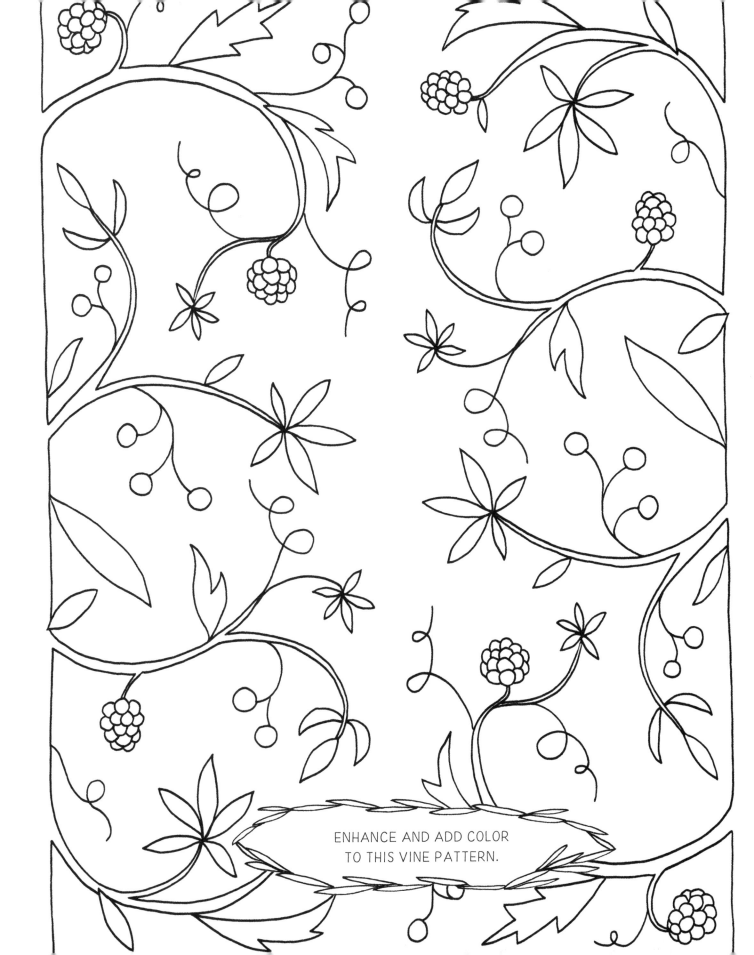

ENHANCE AND ADD COLOR
TO THIS VINE PATTERN.

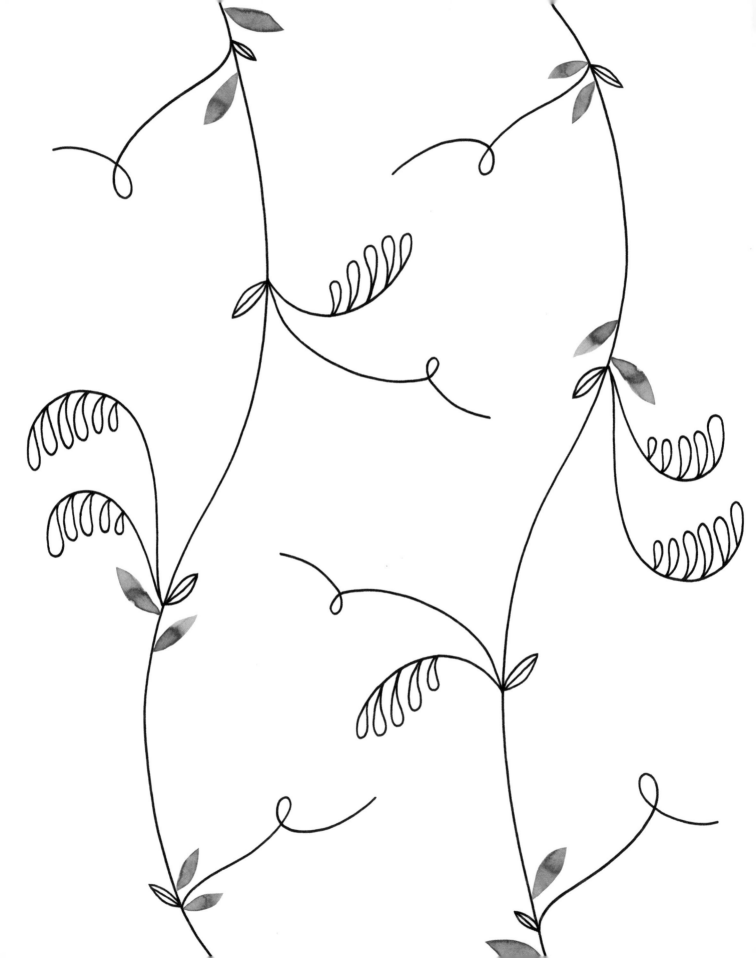

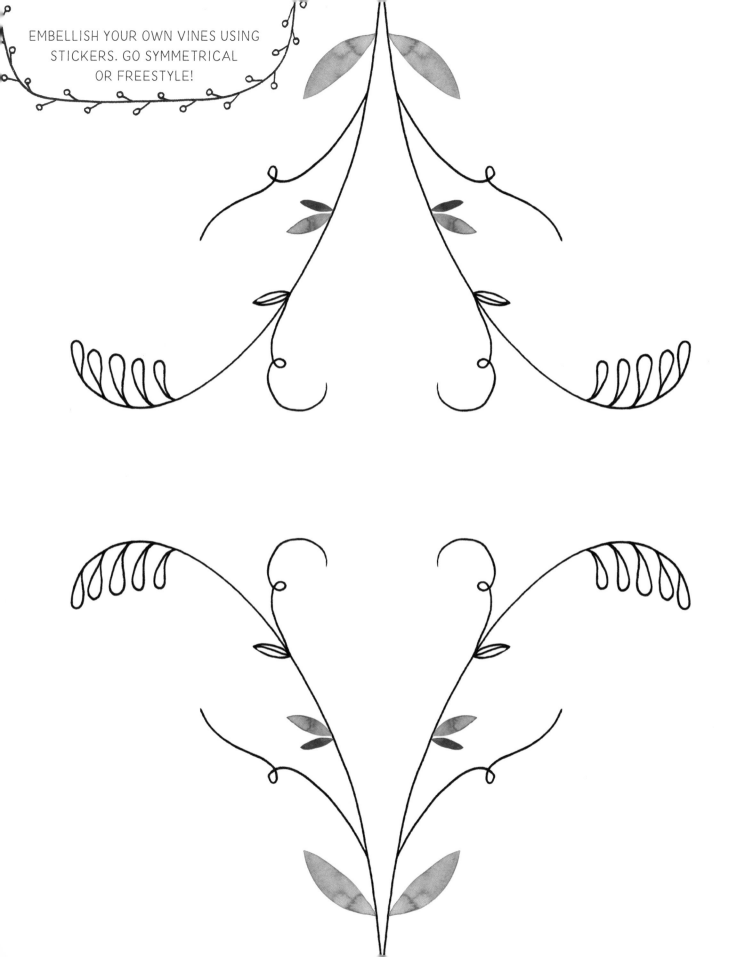

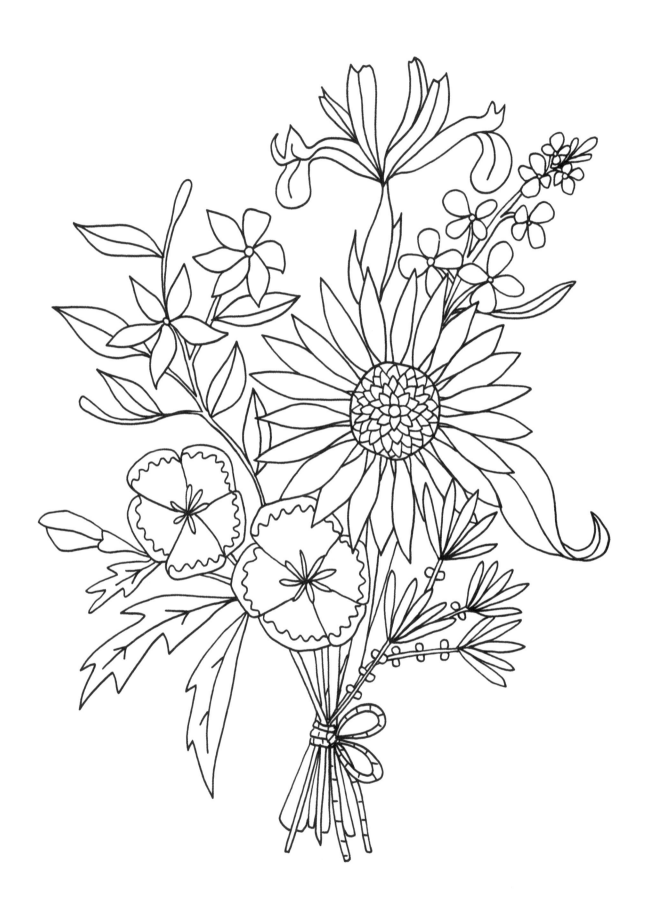

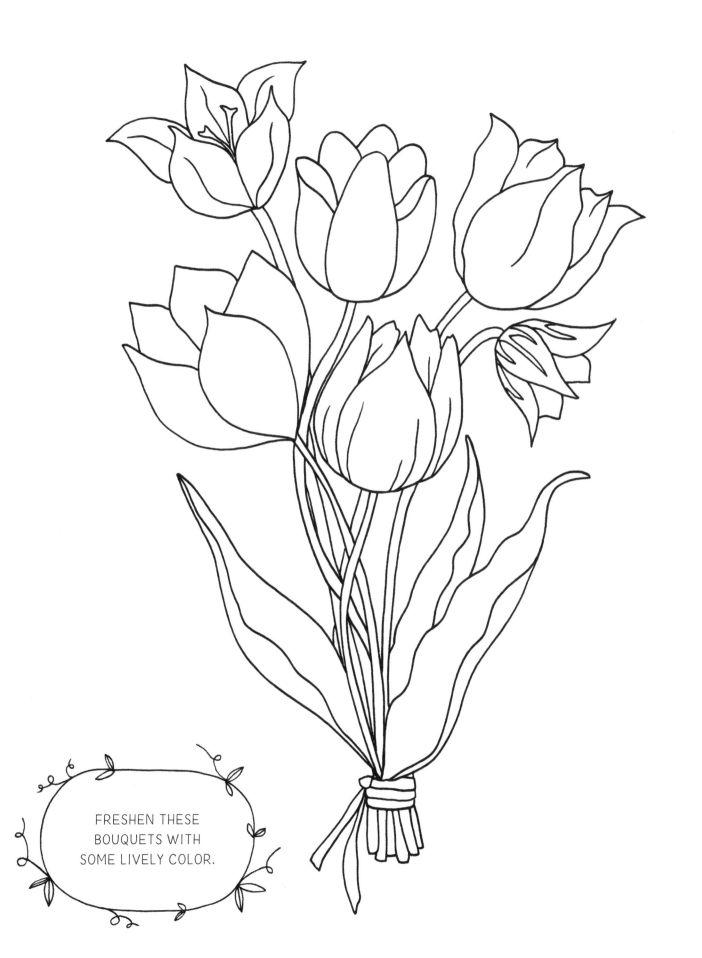

FRESHEN THESE
BOUQUETS WITH
SOME LIVELY COLOR.

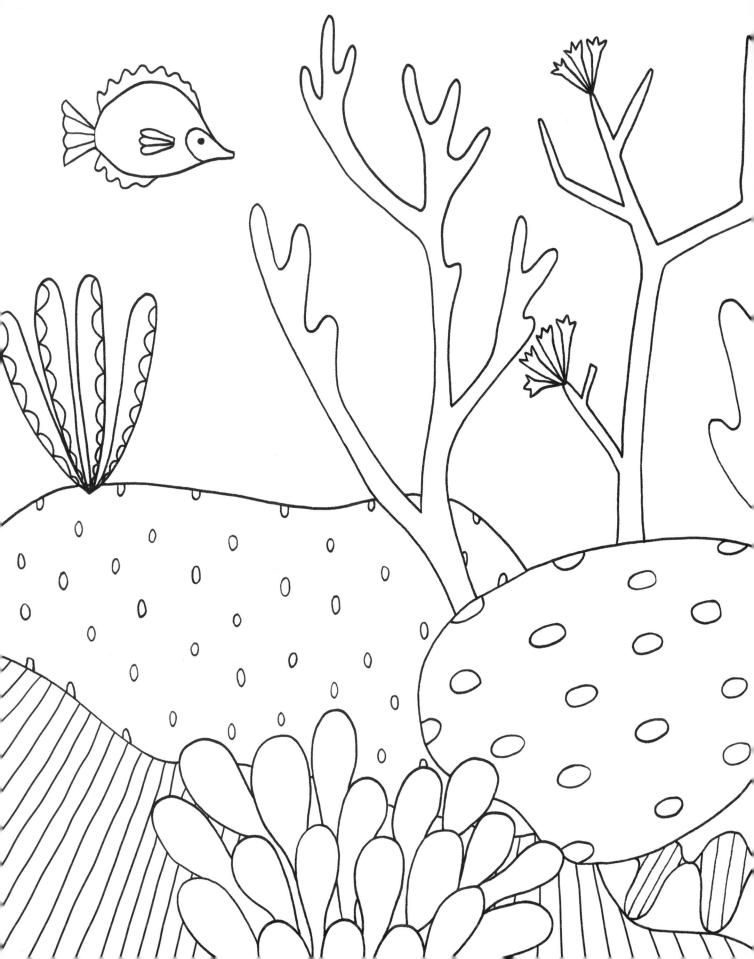

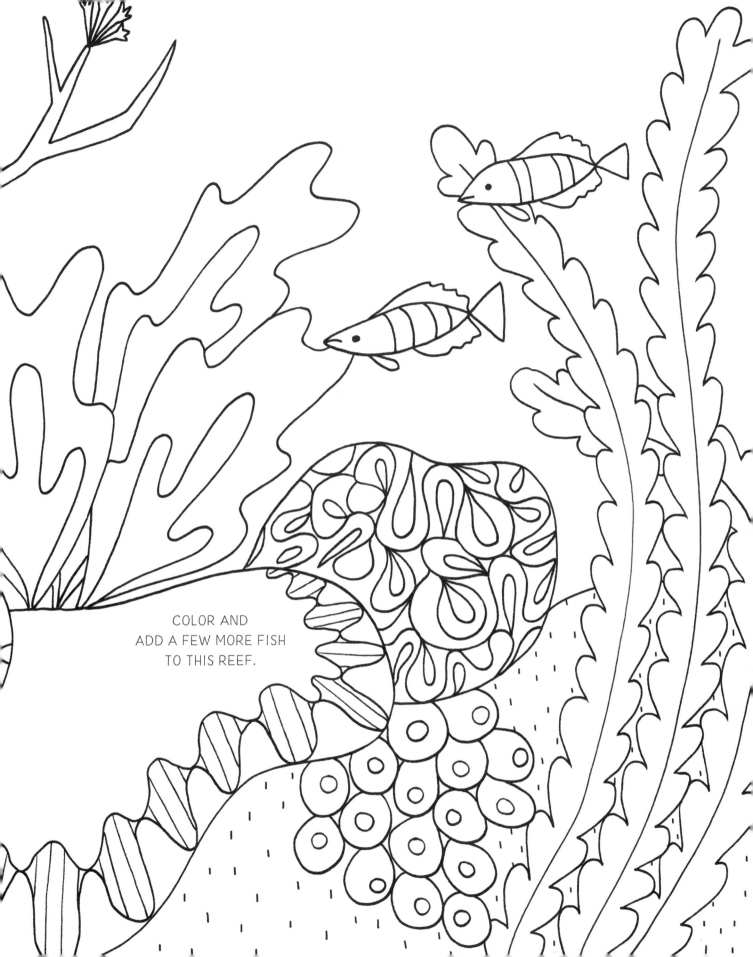

COLOR AND
ADD A FEW MORE FISH
TO THIS REEF.

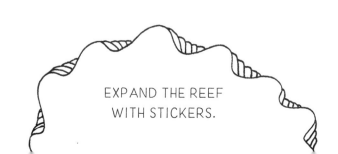

EXPAND THE REEF
WITH STICKERS.

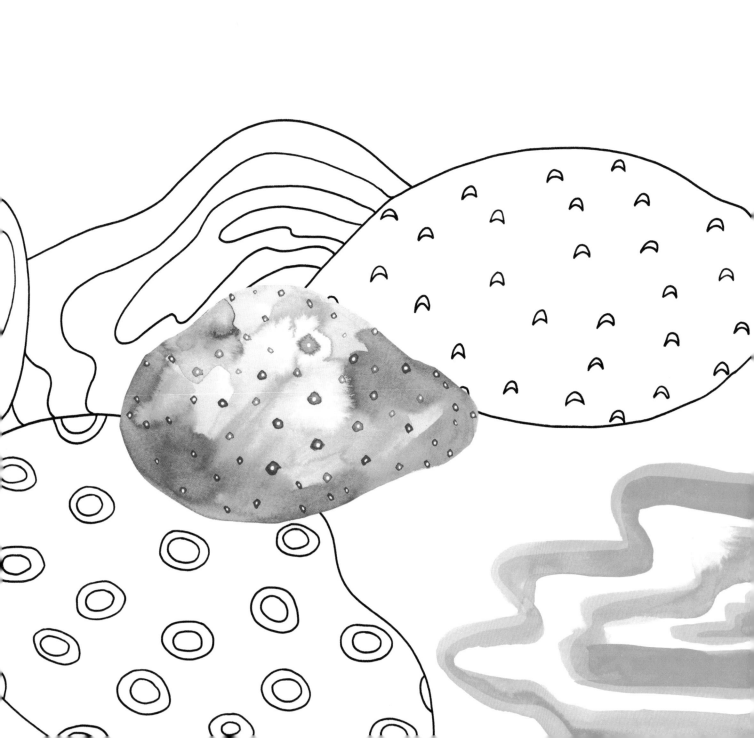

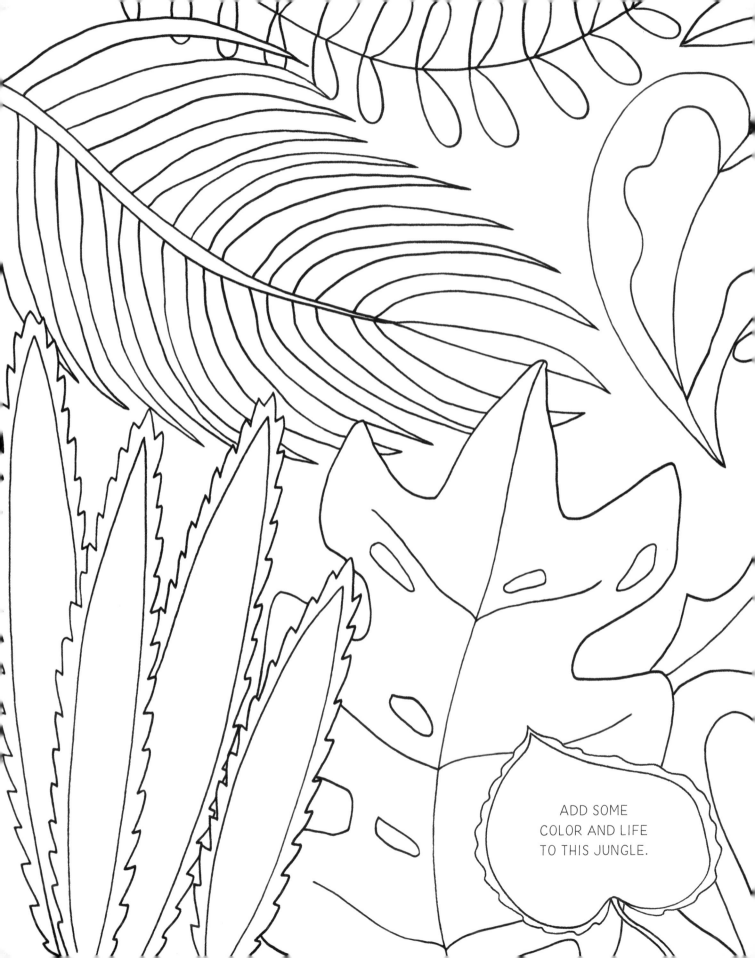

ADD SOME
COLOR AND LIFE
TO THIS JUNGLE.

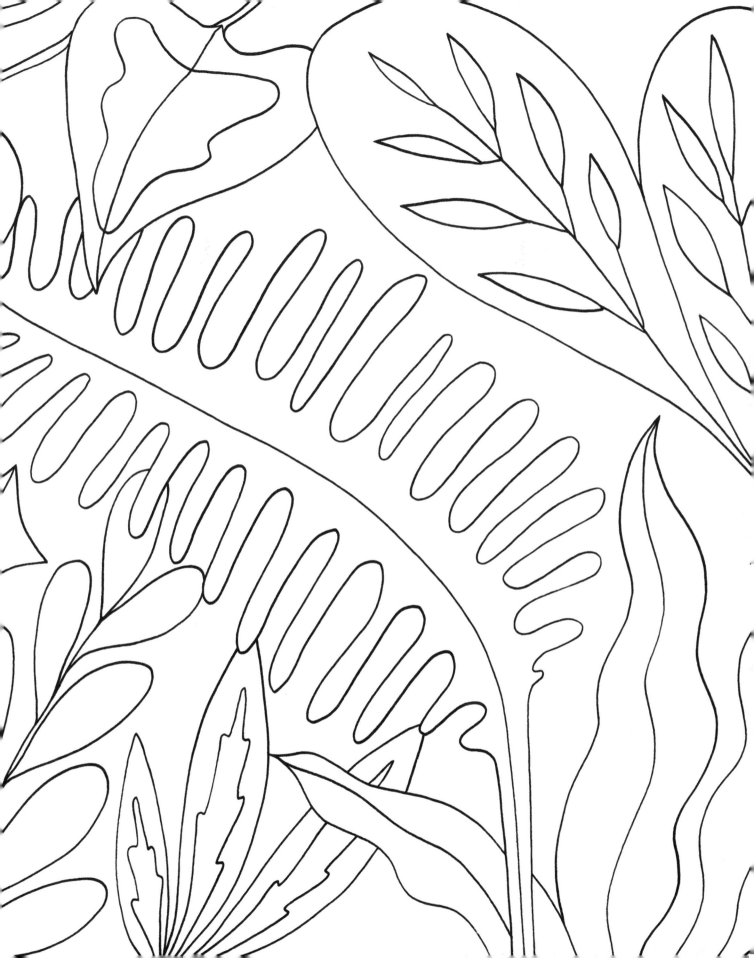

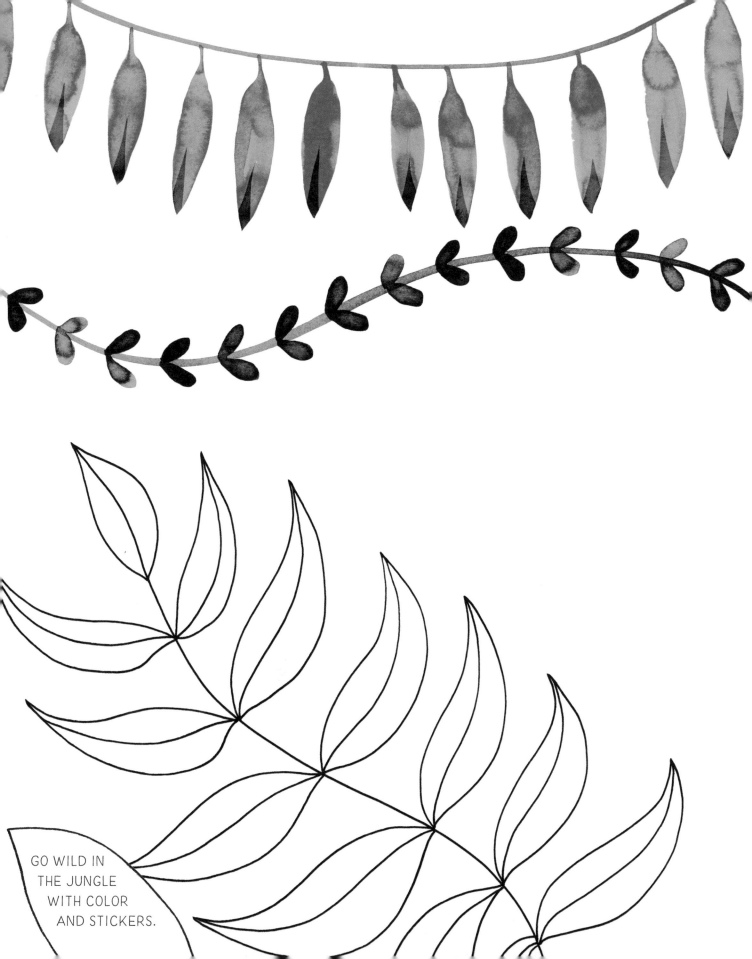

GO WILD IN
THE JUNGLE
WITH COLOR
AND STICKERS.

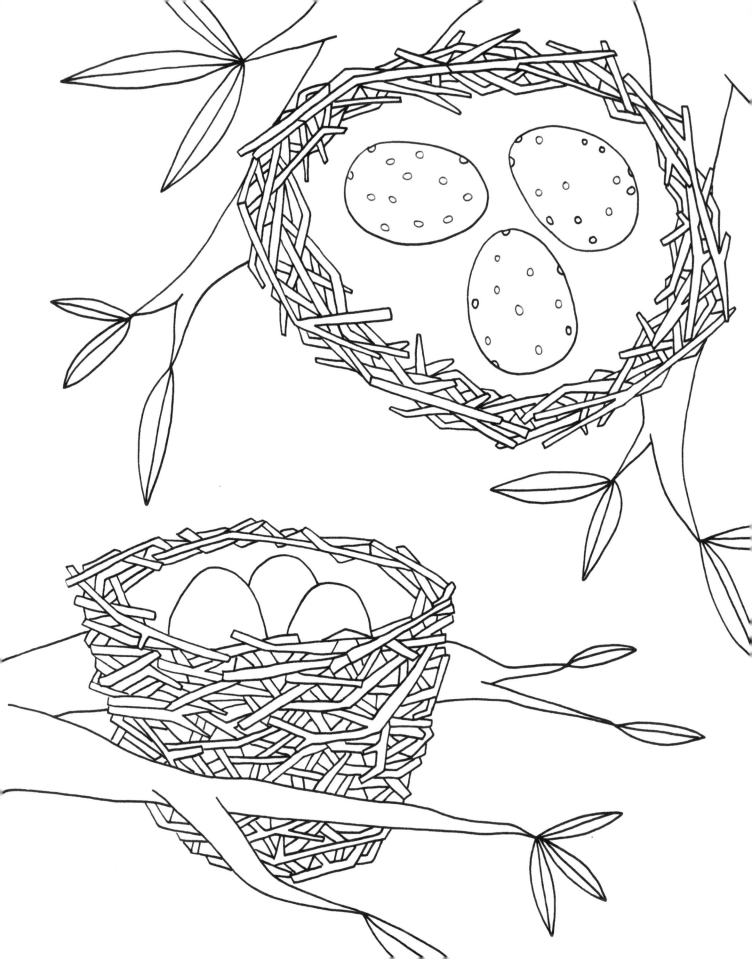

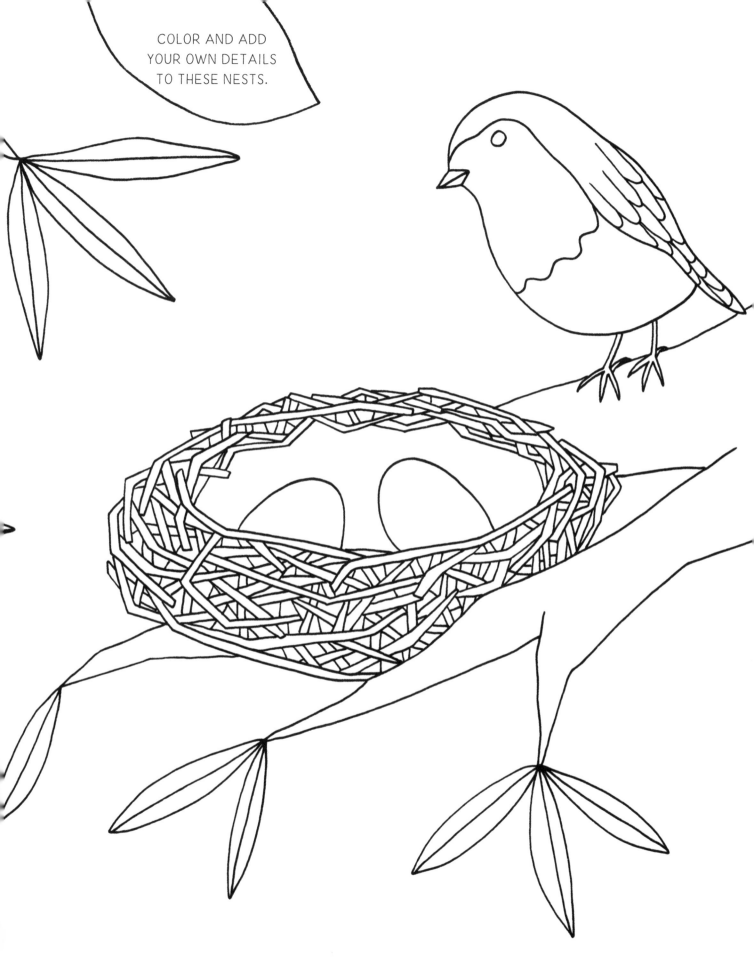

COLOR AND ADD
YOUR OWN DETAILS
TO THESE NESTS.

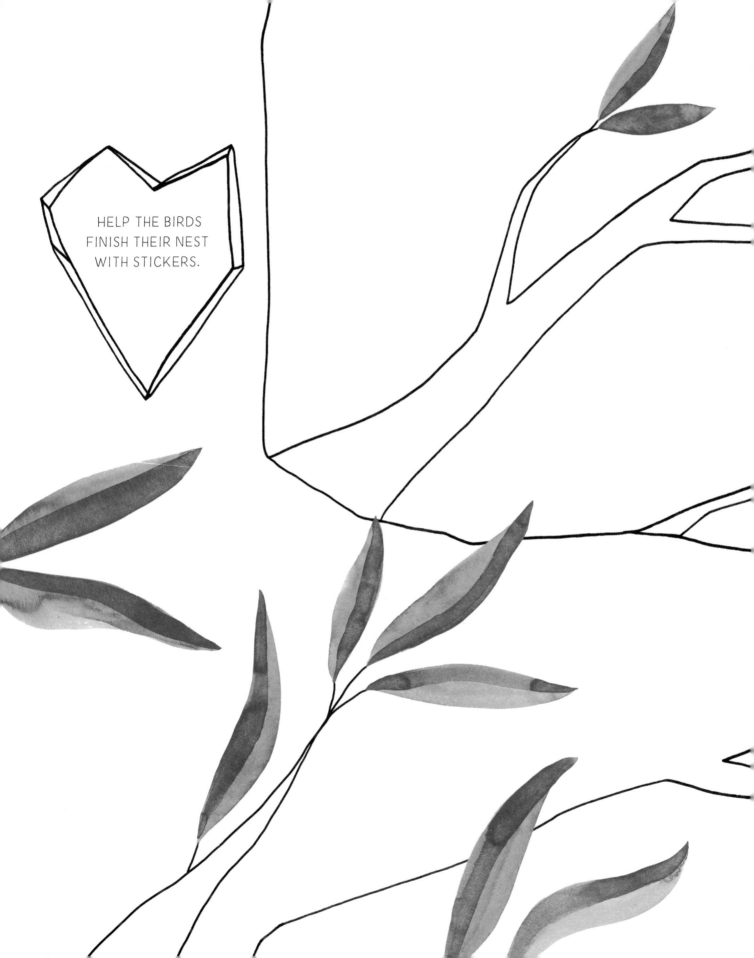

HELP THE BIRDS
FINISH THEIR NEST
WITH STICKERS.

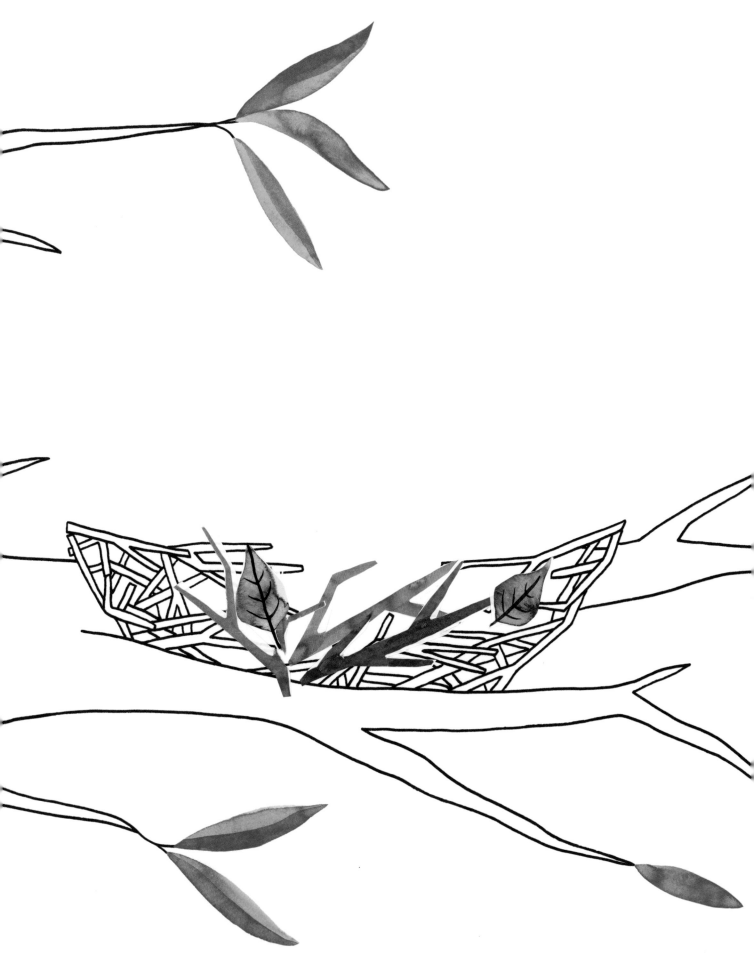

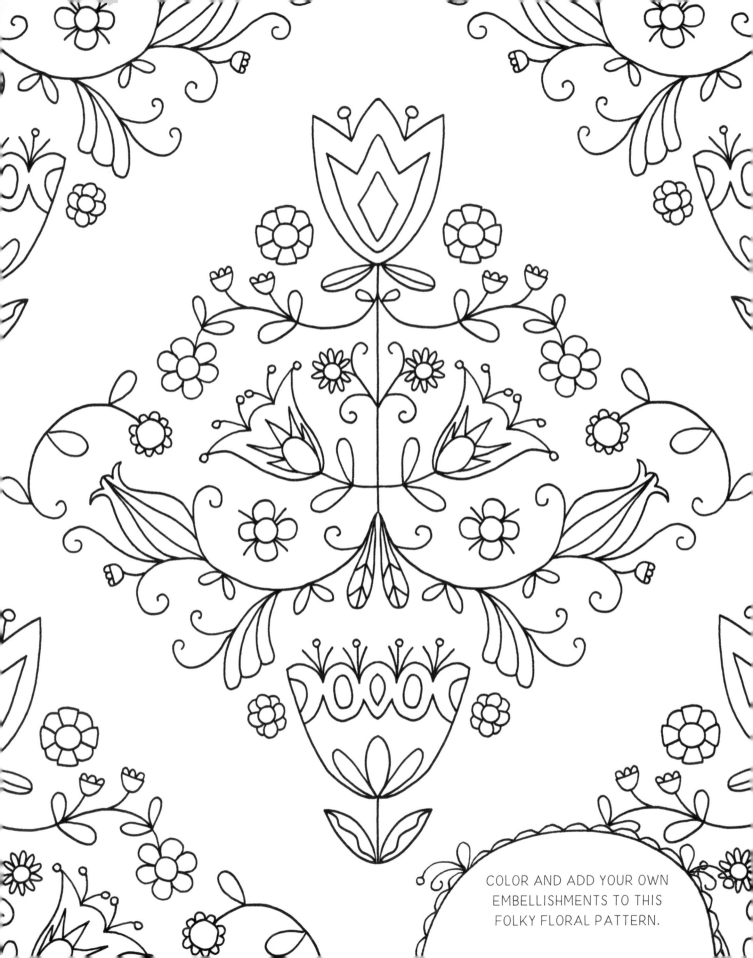

COLOR AND ADD YOUR OWN
EMBELLISHMENTS TO THIS
FOLKY FLORAL PATTERN.

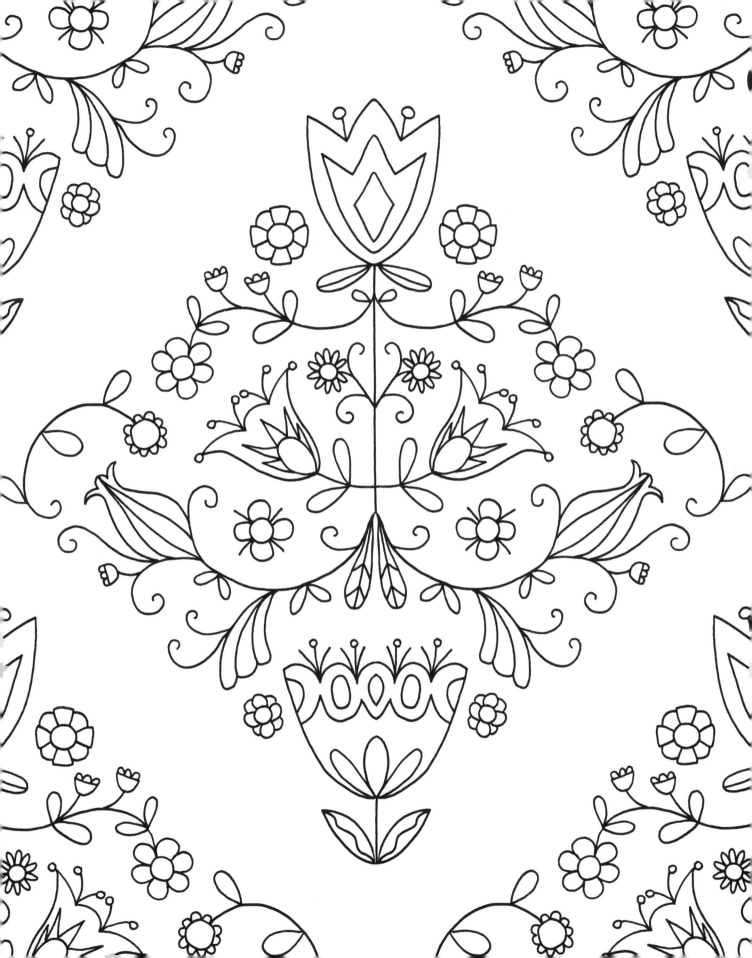

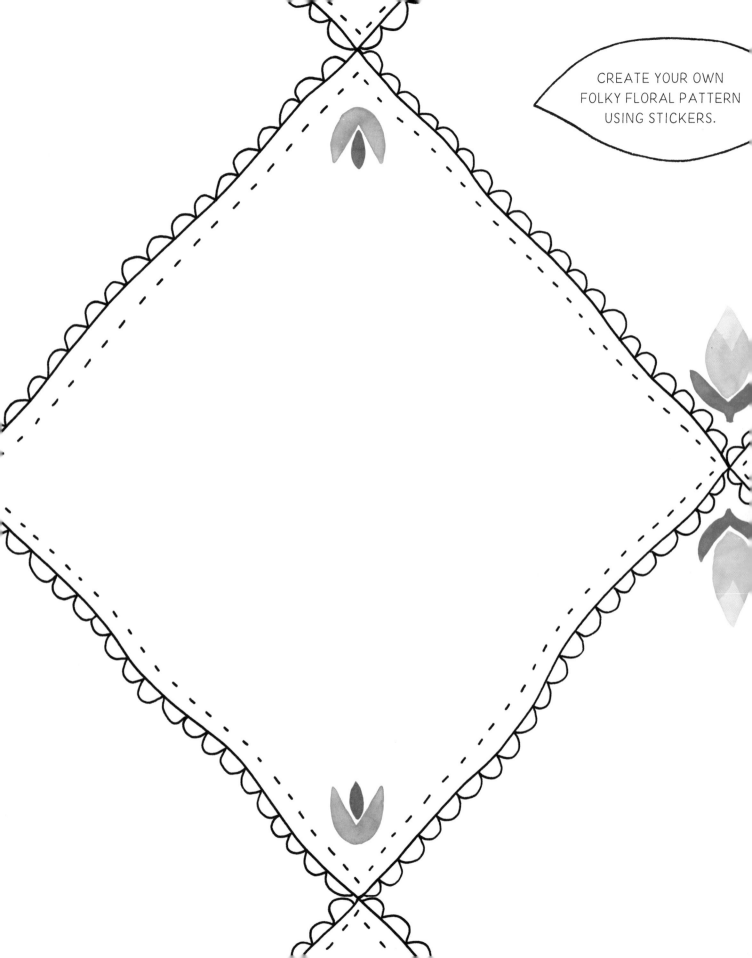

CREATE YOUR OWN
FOLKY FLORAL PATTERN
USING STICKERS.

ABOUT THE ILLUSTRATOR

KATIE VERNON IS AN ILLUSTRATOR WHO HAS SPENT MOST OF HER LIFE IN THE MIDWEST BUT WHOSE HEART BELONGS IN THE MOUNTAINS. SHE IS A TREND LEADER, A MASTER WATERCOLORIST, AND WINNER OF THE 2015 LILLA ROGERS GLOBAL TALENT SEARCH. HER INSPIRATION COMES FROM BEING A FLORIST, WORKING WITH ALPACAS, AND LIVING ON A BUS. SHE'S WORKED WITH IKEA, THE LAND OF NOD, HALLMARK, OOPSY DAISY, AND CHRONICLE BOOKS; AND HAS BEEN FEATURED ON HGTV, DESIGN*SPONGE, AND OHJOY! SOME OF HER FAVORITE THINGS INCLUDE REARRANGING FURNITURE, SELTZER WATER, AND TWO DIFFERENT SPECIES OF ANIMALS BECOMING FRIENDS. KATIE IS ALSO RATHER FOND OF HER PARTNER, DAUGHTER, AND PART-DINGO DOG.

VISIT HER WEBSITE AT WWW.KATIEVERNON.COM OR ON INSTAGRAM @KATIEVERNONART

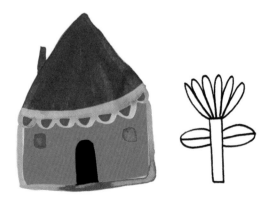

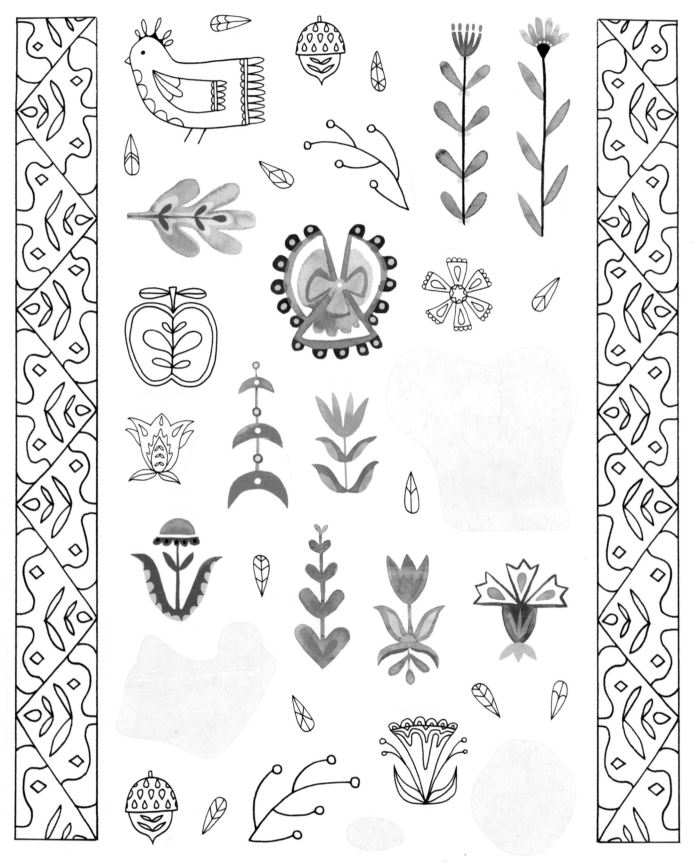

FOLK TREE STICKERS

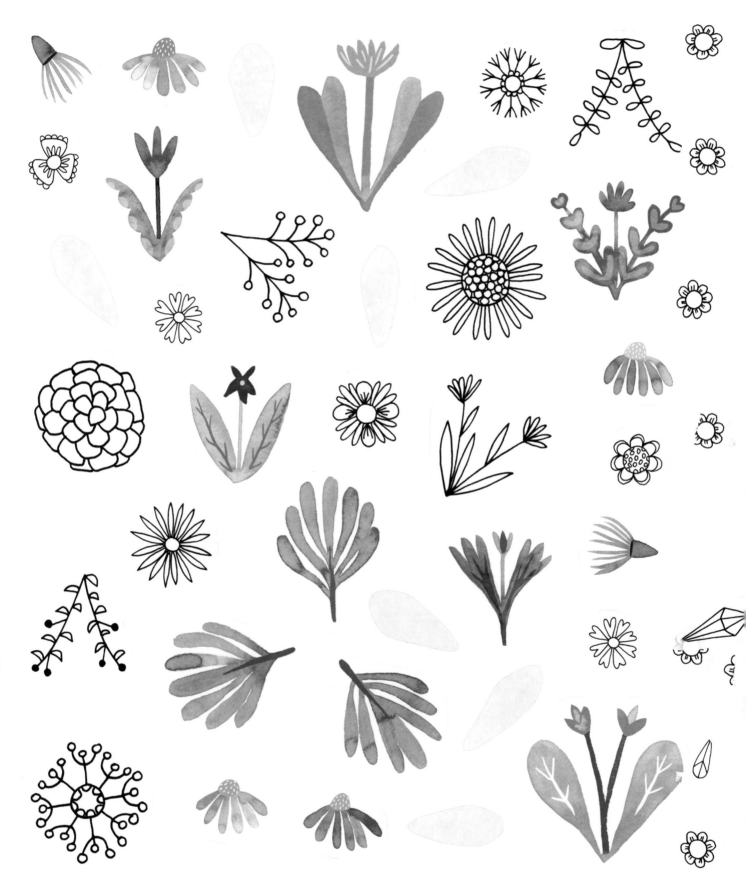

MANDALA STICKERS

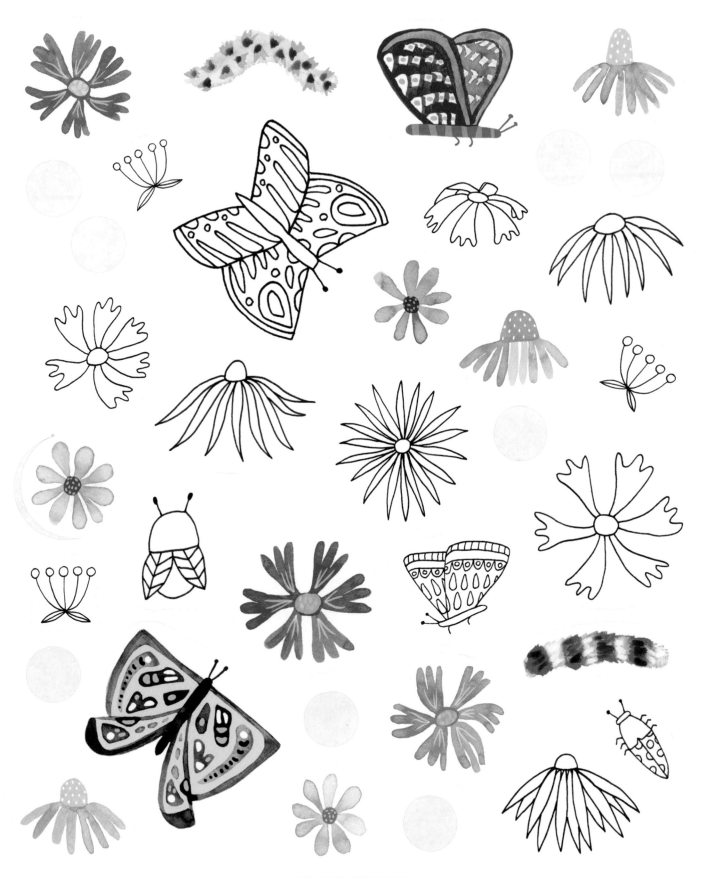

PRAIRIE STICKERS

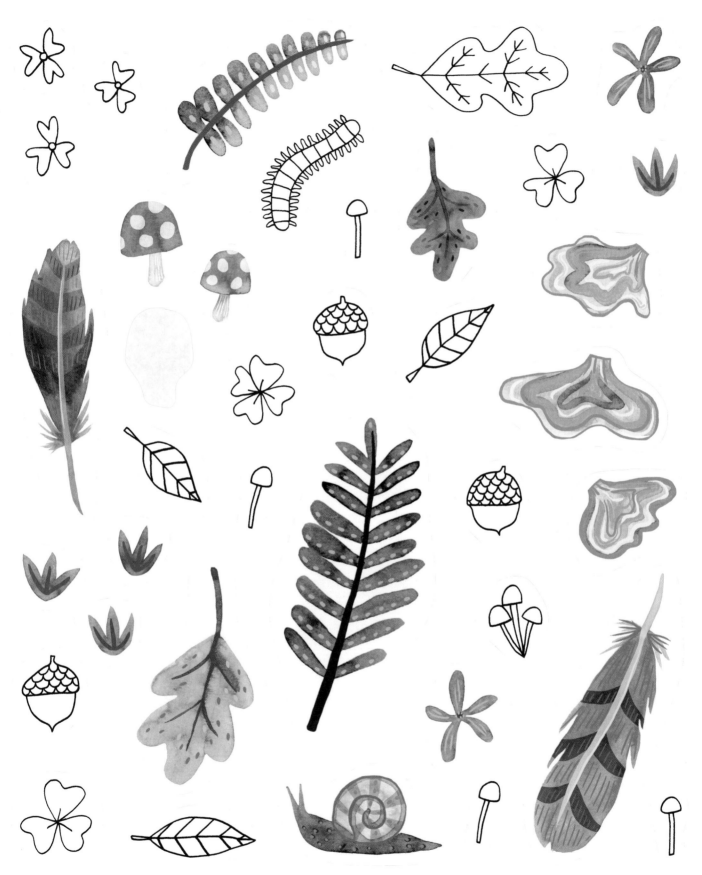

FOREST FLOOR STICKERS

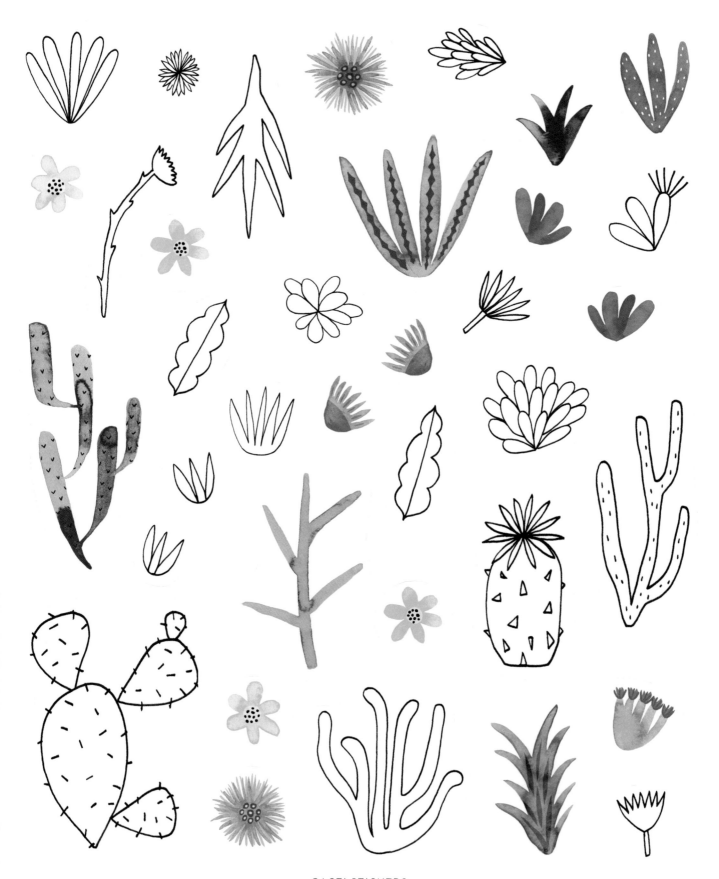

CACTI STICKERS

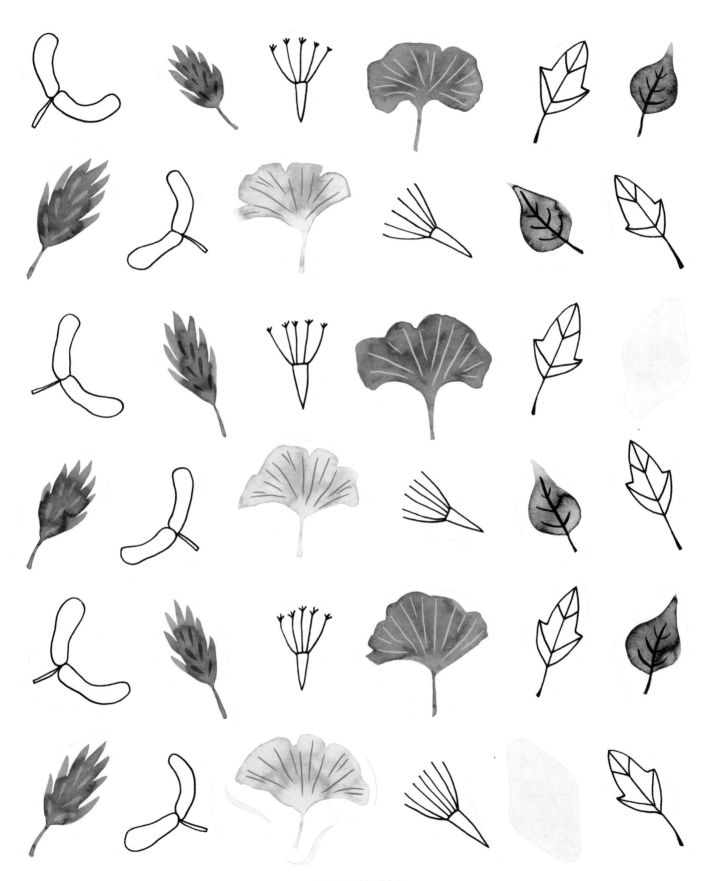

LEAF STICKERS

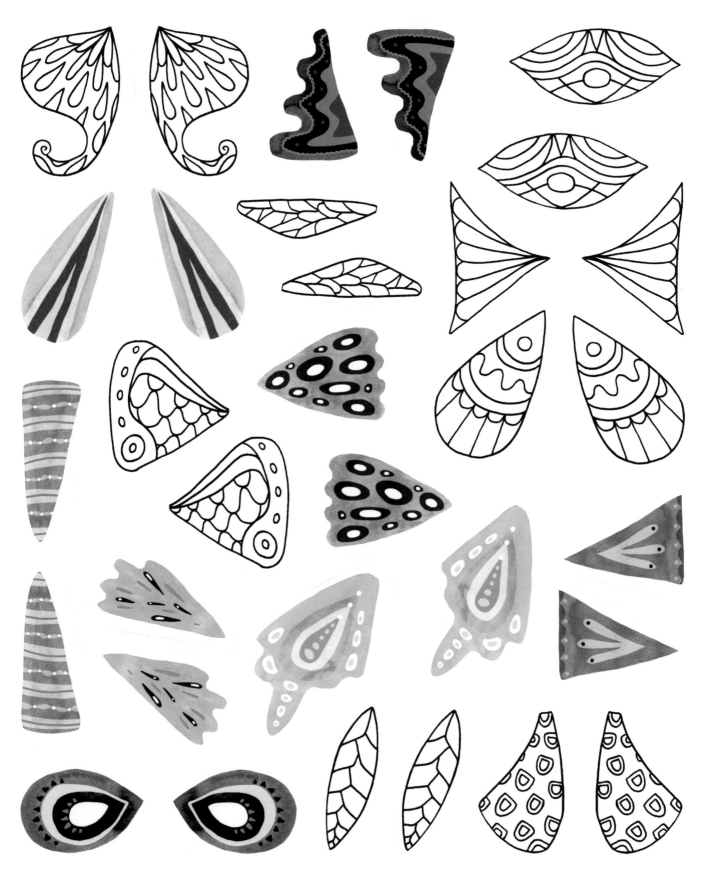

INSECT STICKERS

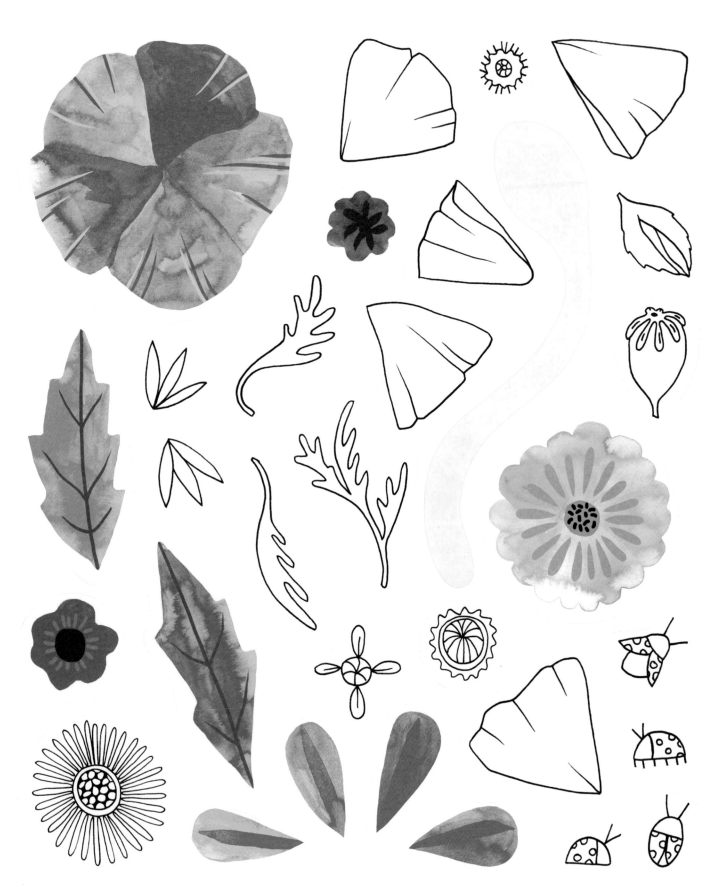

POPPY STICKERS

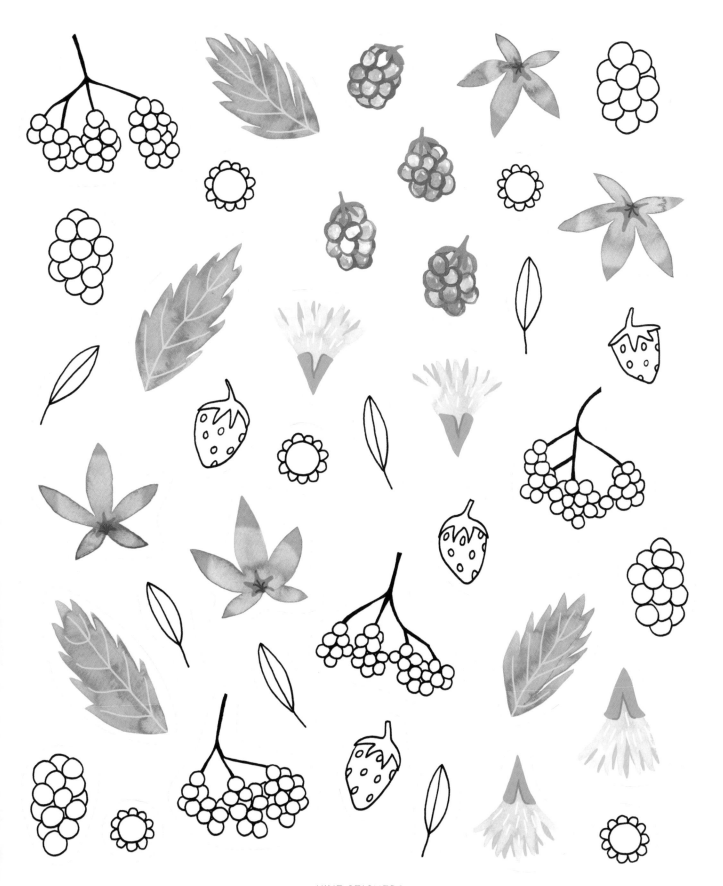

VINE STICKERS

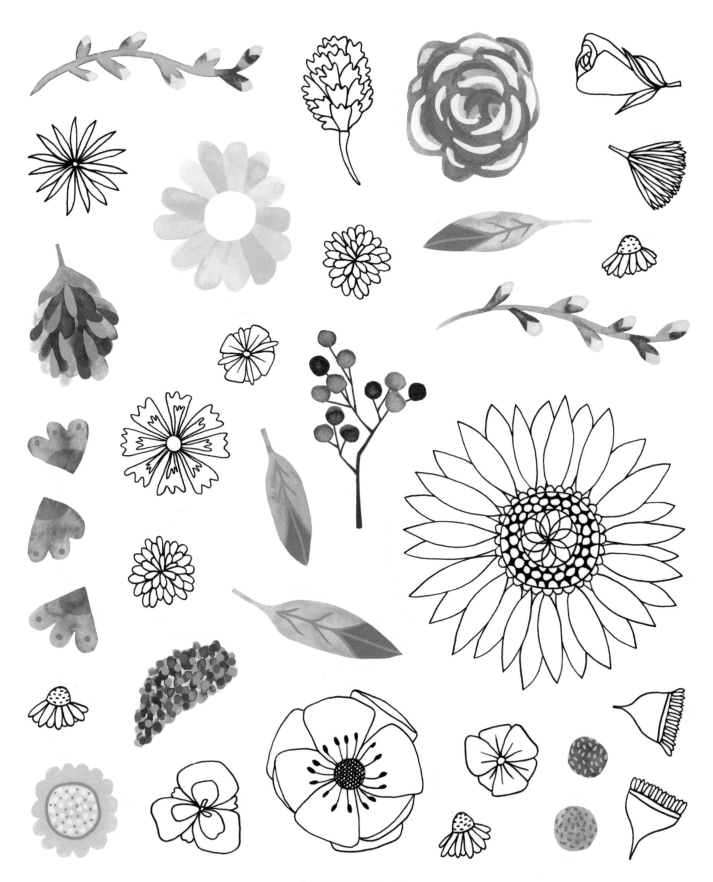

BOUQUET STICKERS

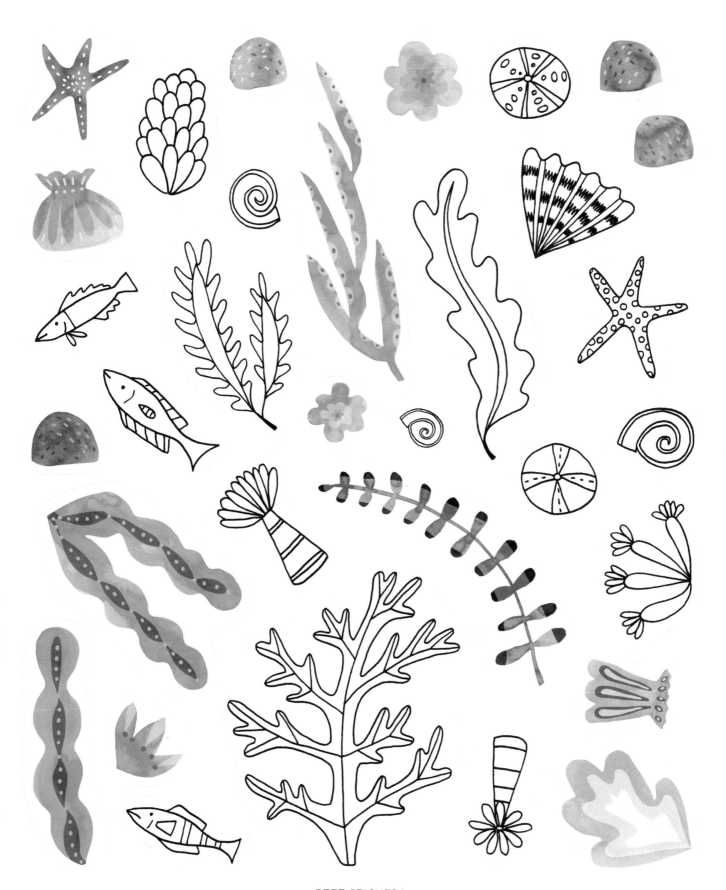

REEF STICKERS

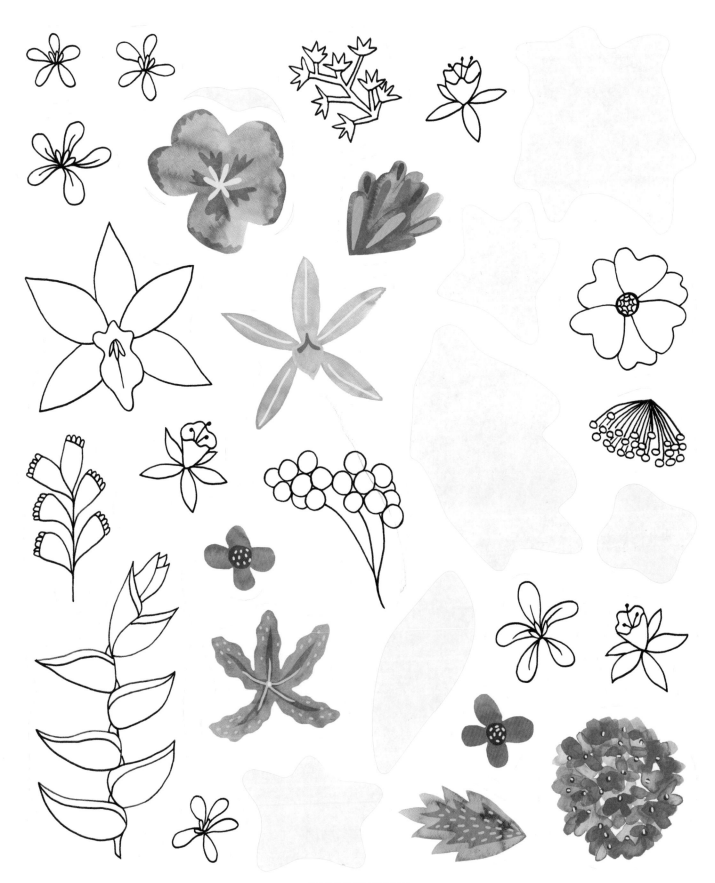

JUNGLE STICKERS

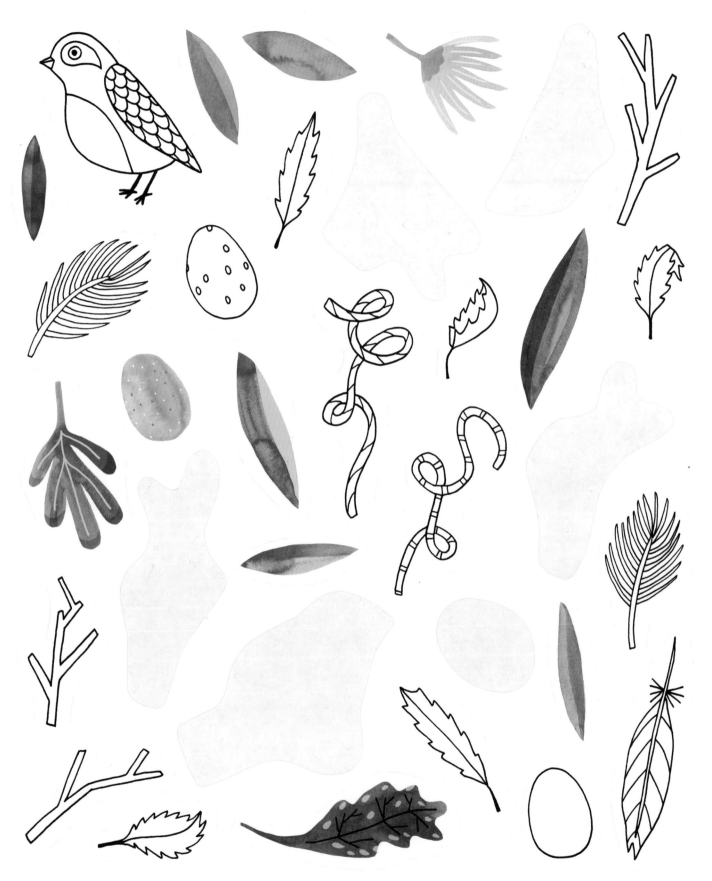

NEST STICKERS

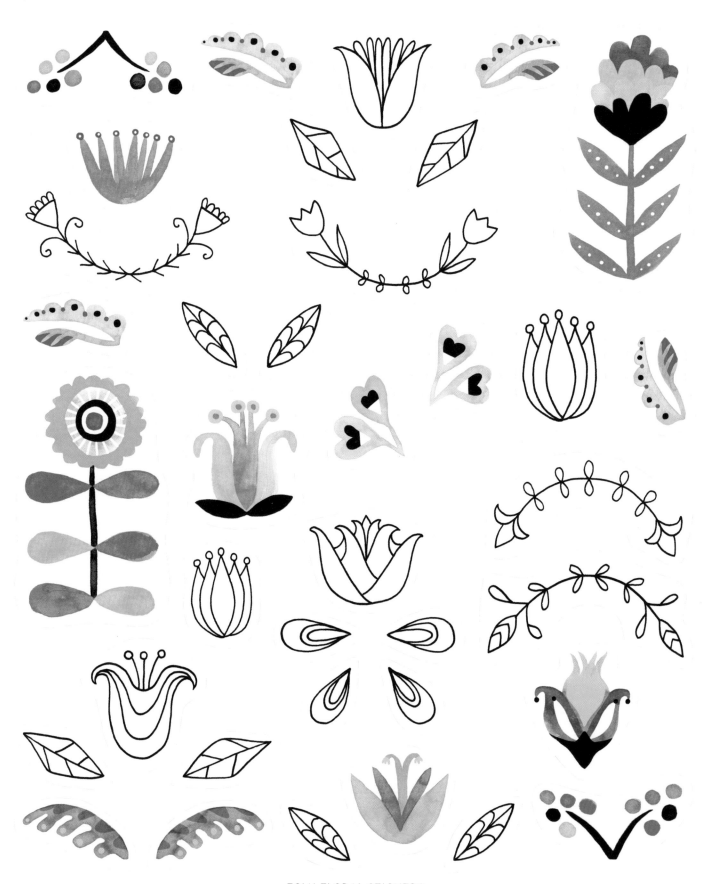

FOLK FLORAL STICKERS

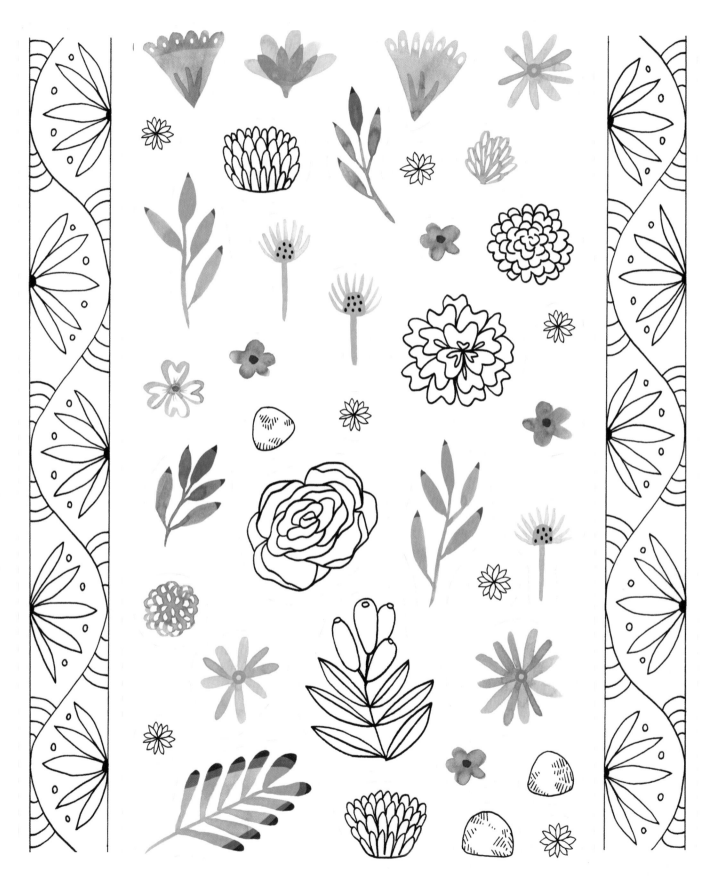

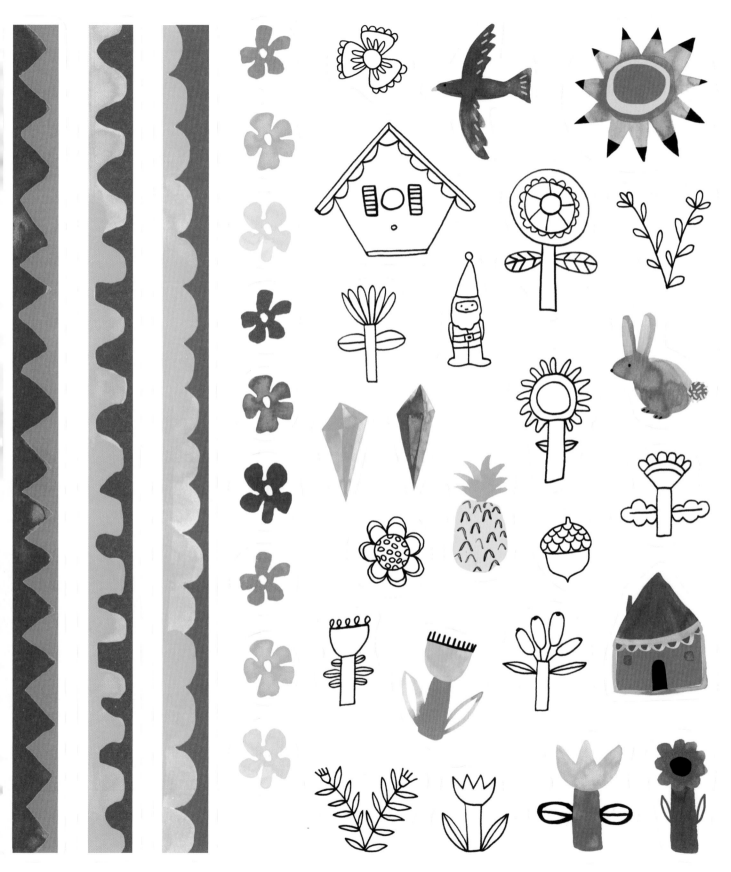